19 95

D0771163

COURTHOUSES OF MINNESOTA

COURTHOUSES

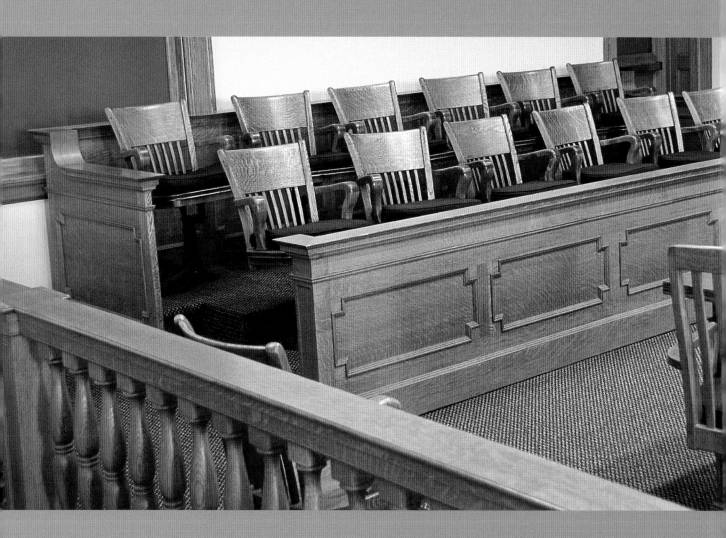

minnesota byways

OF MINNESOTA

Photography by Doug Ohman

Text by Mary Logue

MINNESOTA HISTORICAL SOCIETY PRESS

minnesota byways

Barns of Minnesota
Churches of Minnesota
Courthouses of Minnesota

www.mhspress.org

The Minnesota Historical Society Press is a member
of the Association of American University Presses.

Manufactured in China by Pettit Network, Inc.,
Afton, Minnesota

Book and jacket design by Cathy Spengler Design

10 9 8 7 6 5 4 3 2 1

∞ This book is printed on a coated paper
manufactured on an acid-free base to ensure
a long life.

The photographs on pp. 10 and 18 are from the MHS
Collections; those on p. 101 are courtesy of the Lake
of the Woods County Historical Society and used with
permission.

Photograph, pp. ii–iii: Courtroom inside the Jackson
County Courthouse, Jackson.

International Standard Book Number
 ISBN-10: 0-87351-550-1 (cloth)
 ISBN-13: 978-0-87351-550-4 (cloth)

Library of Congress Cataloging-in-Publication Data

Ohman, Doug.
Courthouses of Minnesota / photography by
Doug Ohman ; text by Mary Logue.
 p. cm. — (Minnesota byways)
Includes bibliographical references and index.
ISBN 0-87351-550-1 (cloth : alk. paper)
 1. Courthouses—Minnesota.
 I. Logue, Mary.
 II. Title.
 III. Series.

NA4472.M6O46 2006
725′.1509776—dc22

 2005030238

COURTHOUSES OF MINNESOTA

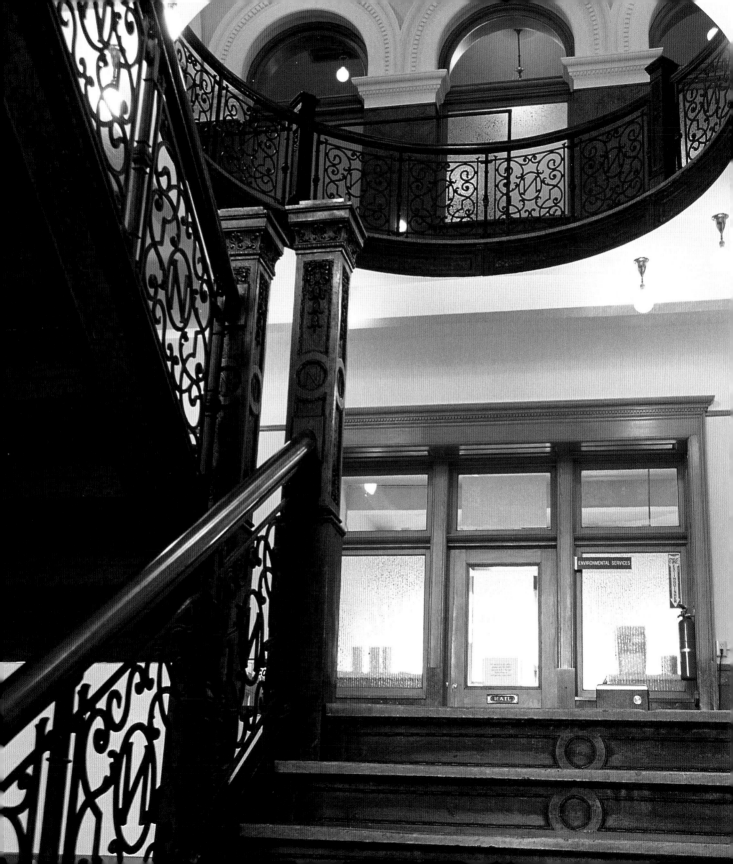

INTRODUCTION

The big dramatic scene always happens in the courtroom. The judge peers down from his bench. The jury watches with a mix of reactions: shock, horror, even revulsion. The defense lawyer has just forced the hapless witness, usually female, to admit that she was covering up something. It's a hot summer day. The prosecuting attorney wipes his brow while the defense attorney turns away from the witness and glances at his lucky client—saved by the right question at the right moment to the right person.

We all grew up with these courtroom dramas, first *Perry Mason* and *Matlock*, more recently *Boston Legal* and *Law and Order*. While real courtroom trials provided entertainment for their communities in the days before television, now television has gone to the courtroom.

When I was asked to write a text to accompany Doug Ohman's photographs of Minnesota county courthouses, these classic courtroom scenes ran through my head. But as I thought about the actual buildings, I decided I would write instead a history of our county courthouses. Their story.

It is not your usual history. Few people appear in this narrative. Buildings dominate. I wander in and out. The story resides in the telling detail: the brass doorknobs, the Art Deco light fixtures, a particular death certificate. Much of this history is made up of ephemera, scraps of paper not meant to last, letting us glimpse odd moments in times gone by.

What surprised me the most as I wrote this book is how it retained the classic narrative structure: births, struggles, deaths, the denoument of the story not really ending but sailing off into the future. And I was delighted to find how much drama there has been in the over 150 years of real courthouse life in Minnesota.

LEFT Rotunda stairway in the Norman County Courthouse, Ada, 1904, National Register (1983)

LAYING THE CORNERSTONE

THE CLOCK TOWER *on the old Hennepin County Courthouse marked time for me as I biked to my waitress job at La Casa Coronado downtown, or drove my Chevy Nova to a bar on the West Bank throughout my twenties. I loved the stability of that heavy stone tower piercing the sky, the numbers glowing orange at night. ¶ Telling time might seem an insignificant use of such an important county building, but I think it's one that illuminates how, from the moment their cornerstones are set in place, courthouses help organize the communities they serve. As I have thought of the many ways courthouses have affected my life, these consistent images of the old clock tower stay with me. ¶ The city has grown up around the old Hennepin County Courthouse, crowding out the view of the tower with, first the Foshay Tower* ☞

in 1929, then the 1974 government center and other much taller buildings that have claimed the sky over Minneapolis. Built across the street from the old courthouse, the Hennepin County Government Center was designed with the 1905 building in mind—the same red granite was used, an underground tunnel connects the two—but still this new twenty-four-story building overshadows the old.

I miss seeing the clock tower as easily in my daily life—the authority of its timepiece, the solidity of its tower—but I'm happy to know it is still there, keeping time over a hundred years after it was set in place.

Many of the courthouses built in Minnesota have clock towers, a very appropriate symbol of their role in a community: regulating the lives of its citizens. With a clock tower, a courthouse becomes metaphor, literally the ticking heart at the center of a county.

EARLY COURTHOUSES

The first court in what is now Minnesota was held in a mill in Stillwater in 1849. Later that same year the first county courthouse in the newly established Minnesota Territory was completed in Stillwater and was used for eighteen years.

Most early courts were held in buildings that were not courthouses: in McLeod County an old log school house in Glencoe was used; in Waseca County the first courthouse was a store in Wilton; the first Carlton County Courthouse was a tavern in a stagecoach stop called Twin Lakes; and Cook County business was conducted in a trading post on a spit of land that extended into Lake Superior.

The very first courthouses were often little more than one-story, wood-frame structures. Kanabec County's first courthouse, built in 1876, was just one room rented to the county for $50 a year. It had a large safe for the county records. In order to save space in the small building, the safe sat partly outside the structure with its door opening into the room.

❖ ❖ ❖

10

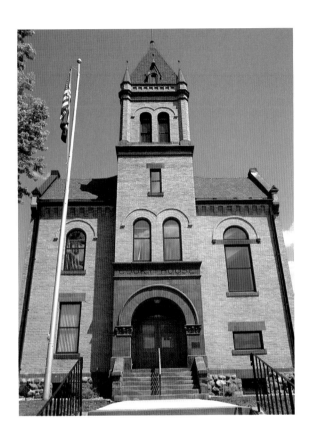

better preserved bones with which to decorate his 'den' and L. S. Parkes secured the upper part of the skull for the school museum."

⊞ ⊞ ⊞

Courthouses were built as soon as counties became established and had a population large enough to support their financing and construc-

Martin County Courthouse was built on what remained of Fort Fairmont. When the foundation for the new courthouse was dug there in 1907, the bones of a young man were discovered. The remains were determined to be those of a white man because of the heavy boot found with him. The *Martin County Sentinel* reported that "Alderman Brodt gathered up many of the

ABOVE, LEFT Kanabec County Courthouse, Mora, 1894, Romanesque Revival, National Register (1977)

ABOVE, RIGHT Clock tower, Martin County Courthouse, Fairmont, 1907, Beaux Arts, National Register (1977)

tion. Great pride was taken in the siting and architecture of these buildings. Usually located in the heart of the chosen town, they were given their own square, often elevated on a knoll or a rise. Dodge County Courthouse in Mantorville, the second oldest in the state, is on a hill which is, of course, called "Courthouse Hill."

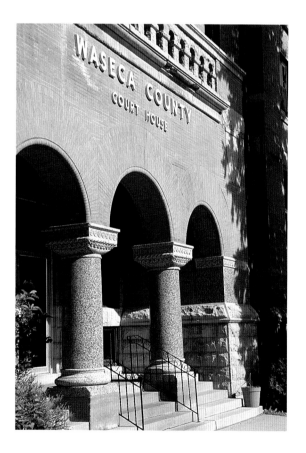

The *Waseca County Herald* described the setting of their new building: "our grand, new courthouse, with its nicely graded grounds and pleasant surroundings."

The courthouse was often the most imposing structure in a county. It was built to hold all the county records and in this way took over some of the duties that the church had filled in the European countries the new settlers had left.

There was a sense in many of the counties that they might never again have the chance to build such a prestigious building. When the Beltrami County commissioners voted to build a new courthouse in 1901, the local paper approved: "Never will the county be better able to afford a courthouse worth the name than today. In a timber country as in a mining section, the loss of its timber and mineral makes it poorer day by day. Public improvements should be made when the natural wealth will pay its just dues to the needs of the people."

COURTHOUSE WARS

Towns fought bitterly over the honor of being the county seat. The two factors that most affected such a decision were: whether a town was centrally located in the county, and whether the town was on a thoroughfare—a river or a railroad. It was truly a life-or-death battle as

ABOVE Waseca County Courthouse, Waseca, 1897, Richardsonian Romanesque, National Register (1982)

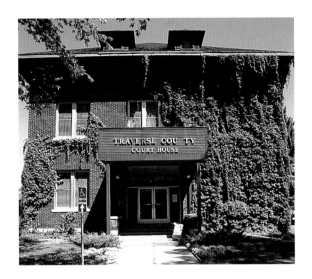

the towns who won the county seat prospered and the ones who lost often disappeared.

Some of the counties that had such fierce county seat fights include: Carlton, Dodge, Grant, Houston, Jackson, Kanabec, Lac Qui Parle, Sibley, Traverse, and Waseca.

One of the longest fights over a county seat took place in Renville County. The first county seat was Birch Couley in 1855. In 1872 Beaver Falls was then declared the county seat, and a few years later, Olivia was pronounced the new county seat. This struggle went on for years.

Across the river Bird Island also wanted to be the county seat and was so determined that the townspeople built their own courthouse. When Olivia finally came out on top, there was a mad rush of wagons and volunteers who worked through the night moving the county records from Beaver Falls to Olivia. The town acted quickly and constructed a classic courthouse in 1902, which is still used today. Beaver Falls is now a virtual ghost town.

A county seat battle that ended in a compromise with neither town winning took place in Le Sueur County. Originally, in 1853, the "seat of justice" was given to Le Sueur, on the Minnesota

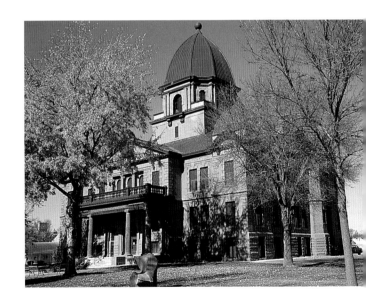

River. Five years later, Cleveland claimed it. It was put to a vote and Cleveland was the winner, but a judge handed it back to Le Sueur. This was just the beginning.

The Le Sueur county seat switched back and forth between these two towns for over twenty-two years. At one point, when a hundred Cleveland townspeople came to claim the county records, the Le Sueur people were prepared and moved the records to a store and posted armed guards.

Finally, as a compromise, the county seat was situated in the geographical center of the county and a town was built around it, called at first, appropriately, Le Sueur Center, then shortened to Le Center. A history of the county states, "the center of a county is the correct position for a court house and with the buildings now erected there no further attempt will likely ever be made to remove the seat of justice of LeSueur county."

The writer of the Watonwan County history agreed: "St. James is the county seat of Watonwan County, and, furthermore, is in no danger whatever of losing this distinction, inasmuch as it is located in nearly the exact geographical center, and is by far the largest and most important city in the county of which it is the capital." So there.

Lac Qui Parle County was witness to a contentious county seat fight among Nassau, Maxwell, and Madison. Madison won and the new county courthouse was to be built in 1899. When the invitations for laying the cornerstone were sent out, one returned from the still-upset town of Maxwell read, "Lay your own corner stone."

And in Grant County the war continues. In July of 2005 the *Herman Review* reported: "Three men dressed as Grant County Highway Department workers . . . staged a daring early morning theft of the recently evacuated cornerstone from the Grant County Courthouse in Elbow Lake." Stealing it right out from under the sheriff's nose, they then threatened to steal the whole courthouse back, "One piece at a time if we have to."

The good people of Herman were immediately suspected as the courthouse had been in their town up until 1882 when, in a predawn raid, the records had been removed to Elbow Lake. Bitter resentment had obviously led to this retaliation 123 years later.

A few days after the cornerstone went missing, it turned up at the Grant County Fair held in Herman. For a $20 donation, you could have

your photograph taken with the stolen stone. The money went to the Grant County Historical Society and the thieves promised they would return the cornerstone to Elbow Lake.

We can be amused, but serious county seat fights continue today. Hastings has worried that it might lose the Dakota county seat and Warroad has tried to lay claim to the Roseau county seat.

⊠ ⊠ ⊠

However, St. Louis County, the largest county in the state, has three courthouses that peacefully coexist. Because of its size, it is divided into three judicial districts. Duluth was established as the county seat in 1862. In 1910, the superintendent of Virginia's schools, Lafayette Bliss, argued for placing a court on the Iron Range, noting that in Duluth, juvenile offenders had to mix with "older, more hardened, offenders."

SECOND- AND THIRD-GENERATION COURTHOUSES

And so the county courthouses were built and rebuilt. Great thought and care and, for the times, large amounts of money were put into these structures.

As was written about the Faribault County Courthouse in 1976,

The tower stands high above the trees and can be seen for miles and miles by the people it serves as they go about their daily routine. . . . As one enters the community and sees the beautiful structure man created with minimal tools and technology of its time, questions of amazement and wonder as to how did they get the huge solid stone of unknown weights to the forth floor of the tower. . . .

As the counties increased in population, they often outgrew their smaller courthouse buildings. In the late 1800s, the Blue Earth County commissioners felt that their current county buildings were a "disgrace and gave strangers an impression that we were behind the times. That the county was either poverty stricken or greatly lacking in enterprise." And so bigger and better courthouses went up.

In 1907 Daniel Burnham, an architect famous for his "City Beautiful" plans in San Francisco and Chicago, was brought to Duluth to design a town square for the St. Louis County Courthouse. He chose to locate it near the gateway to both the railroad and the passenger ship docks.

Many famous architects worked on these second- or third-generation buildings, including: Charles Maybury for the Winona County Courthouse, T. D. Allen for the Steele County Courthouse, and Nairne Fisher on the Rice County and Pope County Courthouses. Fremont Orff

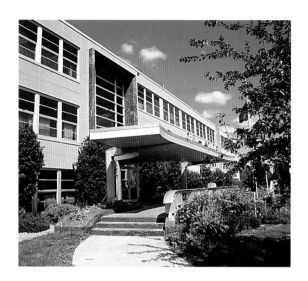

designed Red Lake County, Big Stone County, and Renville County Courthouses, and along with Edgar Joralemon designed the Waseca County Courthouse, too. In the 1950s the firm of Jying and Jurenes designed the new Itasca and St. Louis County Courthouses in Hibbing. Ellerbe Architects were the local associates for the third Ramsey County Courthouse, and designed the new Dakota County Government Center and the newest Polk County Courthouse.

To work on such a building was considered a great honor. In the *Carlton County Vidette,* there was high praise for architect Clyde Kelly who built their courthouse: "Unquestionably, the man who assumes the responsibility of

being the architect for a building like this is entitled to great consideration. To him is left the superintending of the placing of every stock and stone in the building . . . to make the structure as perfect as possible."

Most of the courthouses built between 1890 and 1930 were made of brick and stone. Much consideration was given to the source of this material. Many communities wanted to use the natural resources from their own county; others thought that they needed to go out of state, even out of the country, to get the perfect stone.

In Houston County, the jail was built in Caledonia using the brick from a brickyard close by: "At first they were moulded by hand in the old

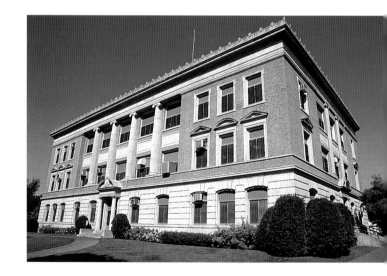

ABOVE, LEFT Itasca County Courthouse, Grand Rapids, 1950, Moderne

ABOVE, RIGHT Carlton County Courthouse, Carlton, 1922, Beaux Arts, National Register (1985)

fashioned way, but about 1870, [the brick-maker] procured a machine, and since that time the manufacture has been extensive."

The "salmon-colored" brick of the old Dakota County Courthouse in Hastings was manufactured in town and goes extremely well with the local limestone.

Stone that was quarried near Superior was used in the Grant County Courthouse, "smoothly dressed and rockfaced coursed ashlar Port Wing brownstone," laid on a granite boulder foundation.

The Faribault County Courthouse used the nearby Kasota stone, which was carted to Blue Earth

> by horse and wagon and by rail. Most of the sand used in the mortar was from the Blue Earth River bottom and thoroughly washed. The mortar was of good quality and lasting as evidenced by inspection of the building today. It is understood by the writer that a good river sand will strengthen with age to approximately 45 years and then begin to slowly deteriorate. The courthouse building with tower is 84 years old and no extensive repairs on the exterior have ever been made. . . .

This statement was written in 1975 and the courthouse is still standing over thirty years later.

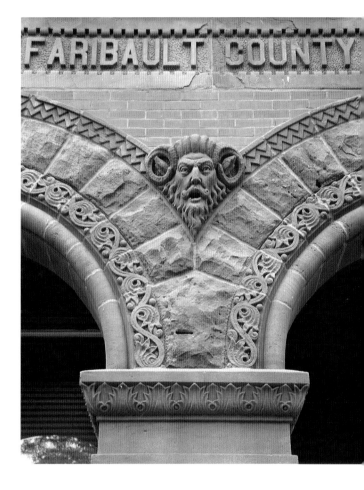

A courthouse's front entrance was given great authority so that a sense of awe and reverence would fall on the people entering the structure. Listen to the tone of the Wilkin County recorder describing the entrance:

ABOVE Gargoyle on the Faribault County Courthouse, Blue Earth, 1891, Romanesque Revival, National Register (1977)

Approaching the Court House from the front, we are impressed with the famous white Bedford stone that is quarried near and named after the city of Bedford, Indiana. . . . There is a cluster of lights around the front doors and as the steps are climbed, the eyes focus on the massive front doors, made from the finest bronze and built to last the lifetime of the structure. As our eyes travel further upward, we see the inscription: "TO NONE WILL WE DELAY, TO NONE WILL WE DENY, RIGHT OR JUSTICE."

While most of the entrances were placed squarely in the middle of the building, the Rock County Courthouse was unique with the main entrance at one of the corners "through a tall circular tower with an open, wooden gazebo on top."

As the Wilkin County Courthouse was built, the commissioners in 1928 had the foresight to install a ventilating system in the attic "in the event air conditioning should become a reality."

❖ ❖ ❖

But some counties prided themselves on erecting a simpler courthouse with not a lot of frills. In 1908 Mahnomen County built their courthouse for $10,000. "Considering the pricetags

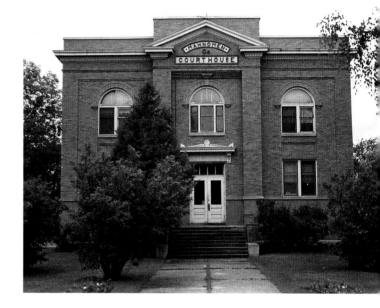

on other courthouses erected in this era, . . . [this] is certainly a mark of economy. There were not a great number of fancy mural, domes, and rotundas, and yet the courthouse is in service today."

The *Aitkin Independent* also bragged about the simplicity of its new courthouse in 1920, "The building appears to be a model in arrangement, with much effort shown in utilising all space to advantage and [serving] the county for years to come. While it will be pleasing to look upon, no money is being wasted on useless ornamentation or show."

ABOVE Mahnomen County Courthouse, Mahnomen, 1909, Classical Revival, National Register (1984).

The *Bemidji Pioneer* in 1902 extolled the virtues of one particular aspect of Beltrami County's brand new courthouse:

> One thing is worthy of note in that although most of the work of finishing was taken up by outside companies, the plumbing was put in by a Bemidji company. The work is done in a workmanlike manner and it is a source of congratulations to the city that we have a company that can take a piece of work of this nature and carry it through so successfully as did the Jerrard Plumbing company in this instance.

▨ ▨ ▨

Huge celebrations were given in honor of the new courthouses. In St. Louis County all the places of business were closed in the afternoon from two to four and "the citizens turned out en masse to the ceremonies attendant upon the formal dedication of Virginia's new hall of justice."

The *Freeborn County Standard* wrote of its new courthouse: "The work is a conception of highest genius . . . acknowledged by all familiar with it. The cost of the completed structure . . . is $75,000, and it could not be duplicated for this sum."

The *Milaca Tribune* wasn't quite so hyperbolic in reporting the opening of the Mille Lacs County Courthouse, "This was the first meeting of the commissioners in the new court house, occupying their own quarters on the second floor over the county treasurer's office. The names of the various offices have been painted on the doors so it is easy to find them." ▨

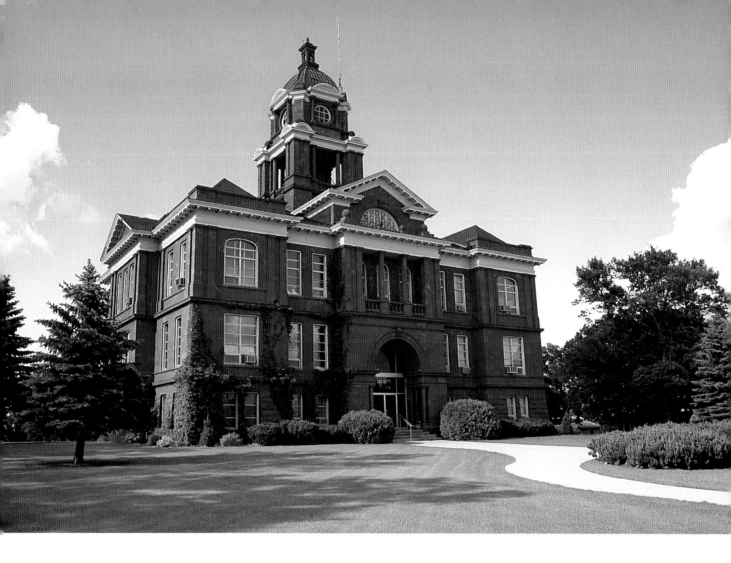

ABOVE Grant County Courthouse, Elbow Lake, 1906, Beaux Arts, National Register (1985)

BELOW Dodge County Courthouse, Mantorville, 1865, Greek Revival/Renaissance Revival, National Register (1974). Oldest courthouse still in use in Minnesota.

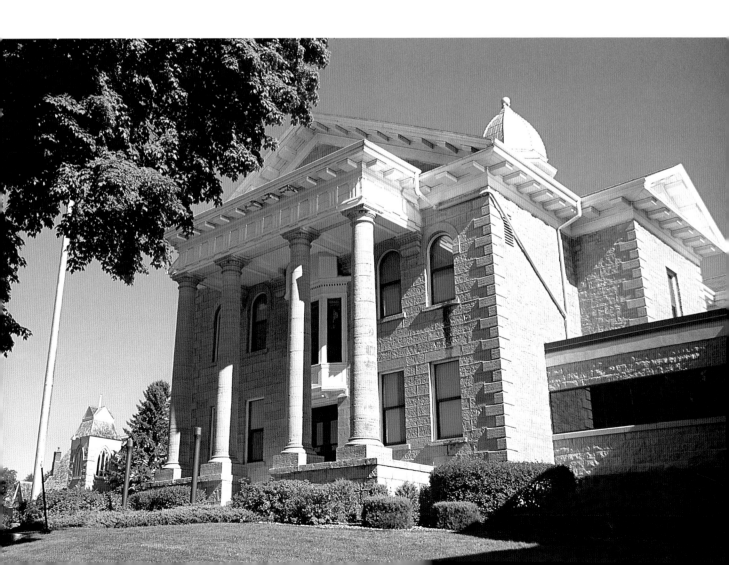

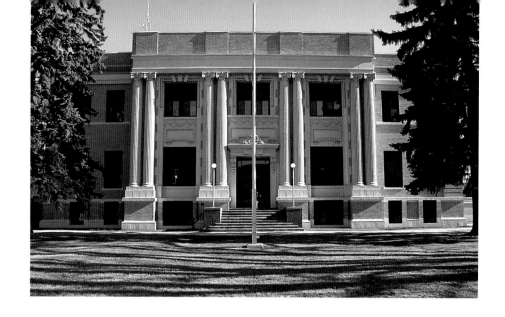

ABOVE St. Louis County Courthouse, Virginia, 1910, Beaux Arts, National Register (1992).
One of three courthouses in Minnesota's largest county.

BELOW St. Louis County Courthouse, Hibbing, 1954

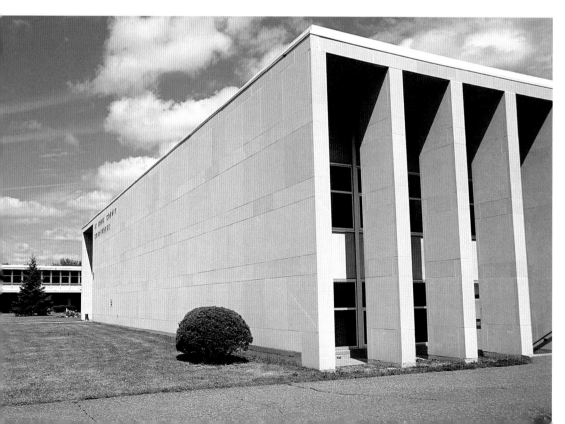

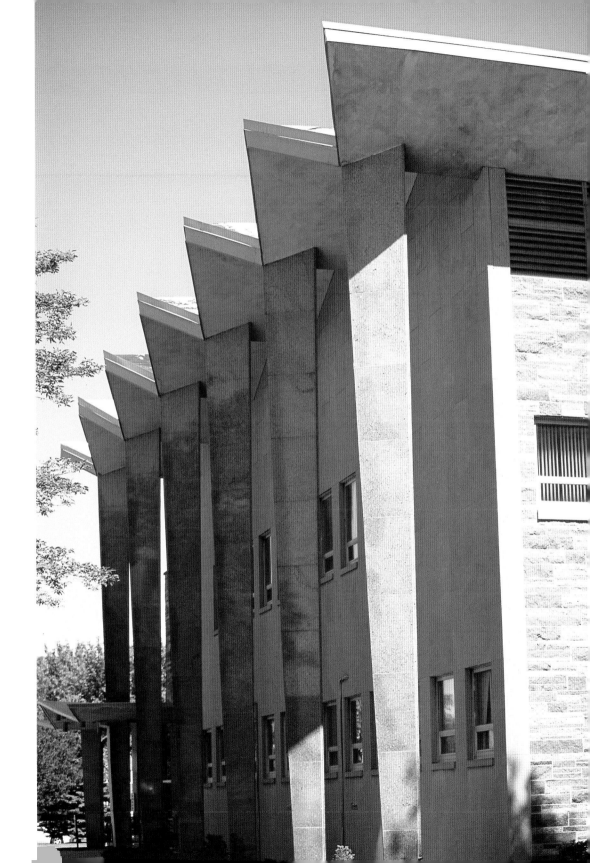

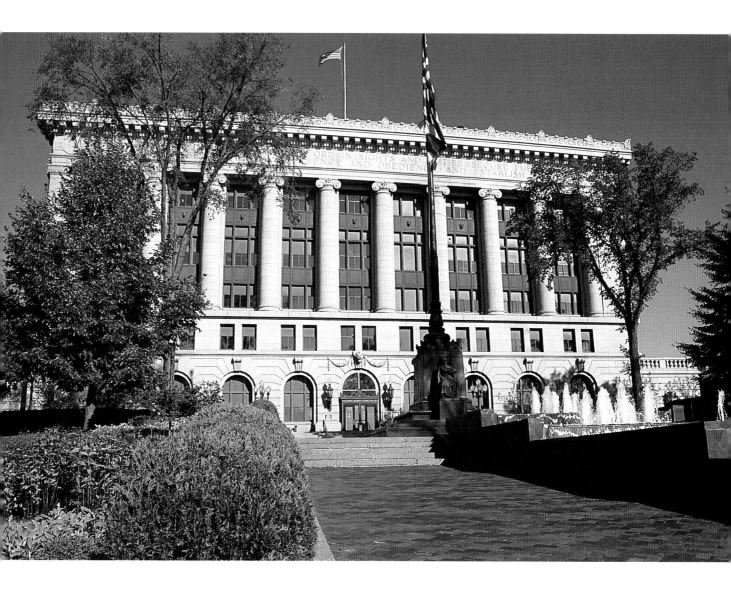

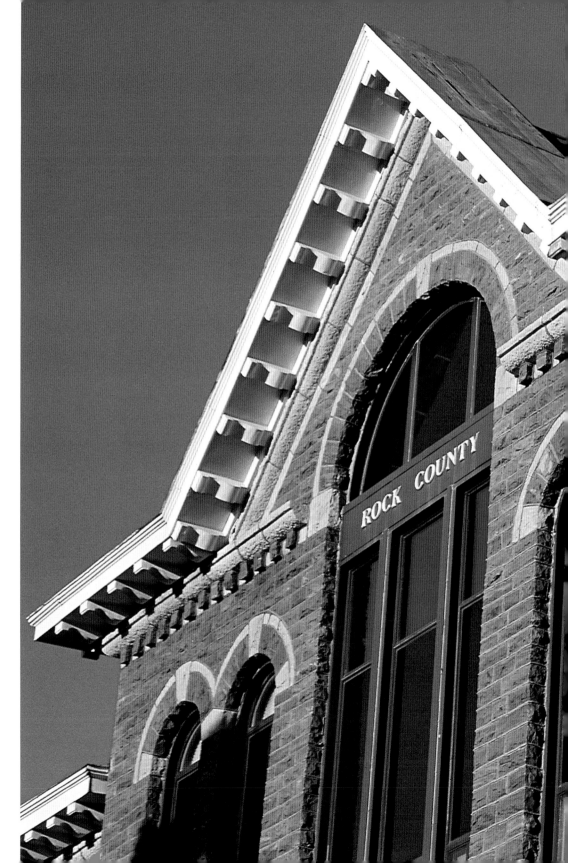

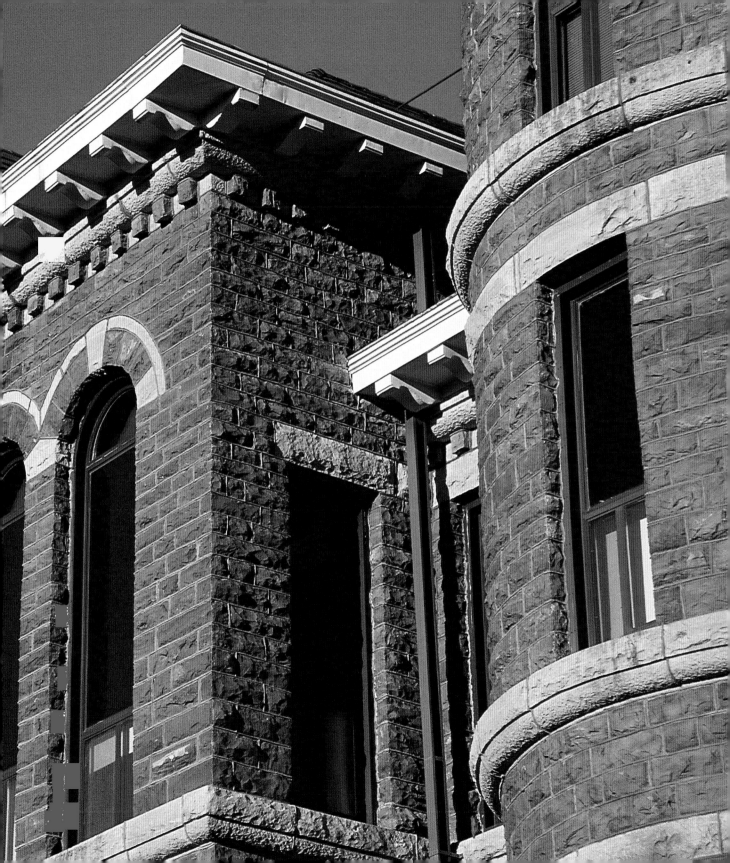

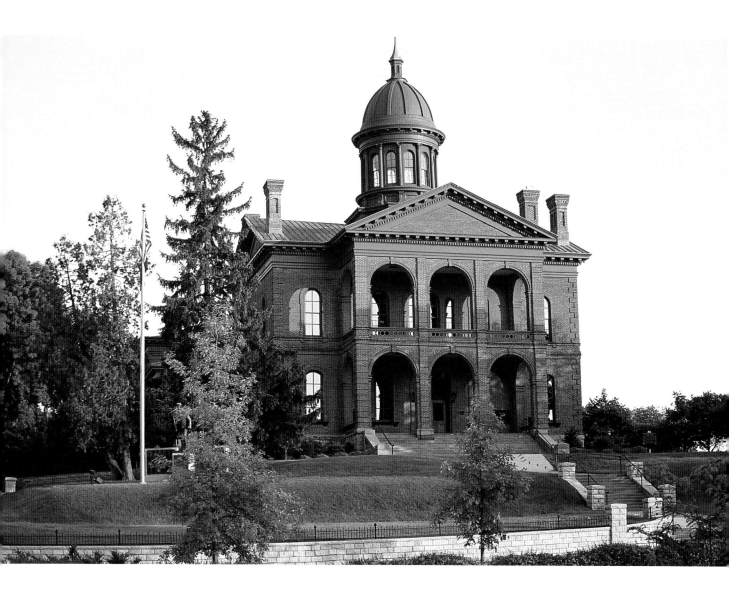

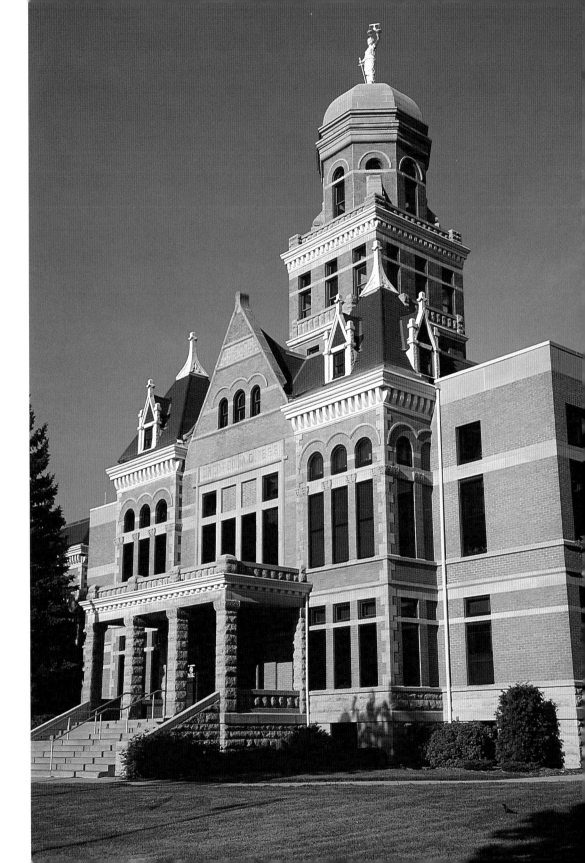

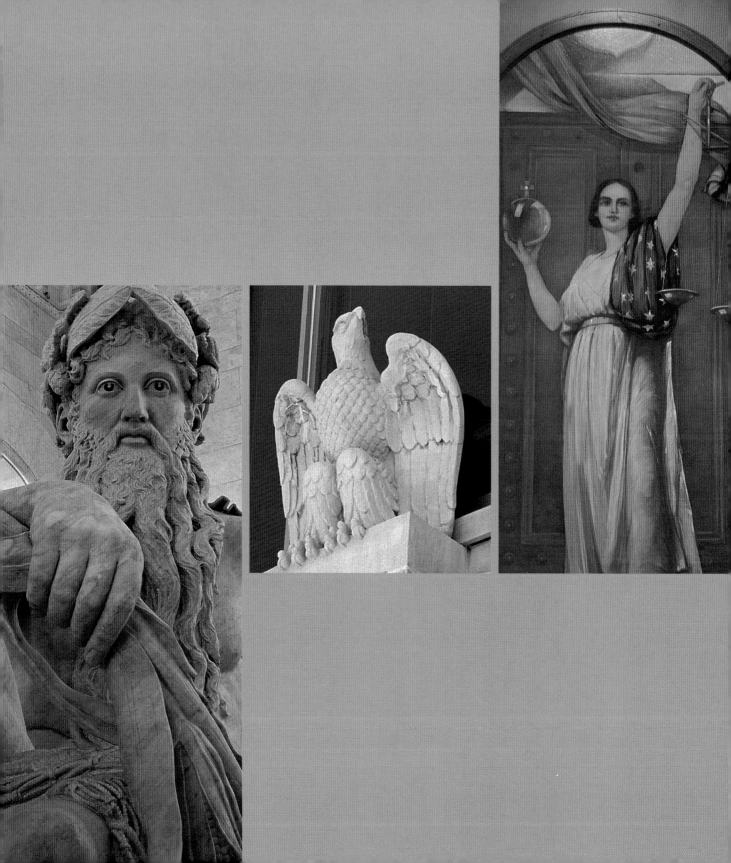

KEEPING WATCH

GROWING UP *in a St. Paul suburb, I always knew about the enormous "Indian" in the Ramsey County court building. I remember staring at a postcard of it and being amazed by how big the statue seemed and how much it glowed.* ¶ *But, until I started work on this book, I had never seen the real statue. So early one summer afternoon, I walked in the Kellogg Street entrance of the courthouse. Recent renovations made it look as crisp and smart as it must have on opening day in 1931. The gold-leaf ceiling of the entrance was restored twelve years ago—a guard told me it rained gold flakes for days while they were working on it.* ¶ *I came at the war memorial from the back, not the most effective way to first see the* God of Peace, *or as the statue was re-named in 1994,* Vision of Peace. *But even from that* ☛

angle he overwhelmed me with just what I had perceived in the postcard: his size—he's absolutely huge, three stories tall; and his glow—the Mexican onyx he was made from has its own golden effusion.

Both courthouse entrances are cluttered with security machines and guards but by standing in the right place and squinting my eyes, I imagined the main floor concourse in full splendor: the Belgian black marble walls set off the glowing onyx statue the way black velvet shows off a diamond.

Of all the pieces of art in all the Minnesota courthouses, the *Vision of Peace* is certainly the most magnificent and possibly the most controversial.

The idea for a statue came when the architect, Thomas Ellerbe, felt something was missing in the main concourse. To placate World War I veterans, it was decided a statue designed as a war memorial would be placed at the far end of the hallway. However, Carl Milles, the Swedish artist who was chosen for the project, was a "confirmed pacifist." So the planning committee decided the statue could celebrate peace instead.

Milles' original four maquettes are displayed in the lower concourse of the building. I certainly

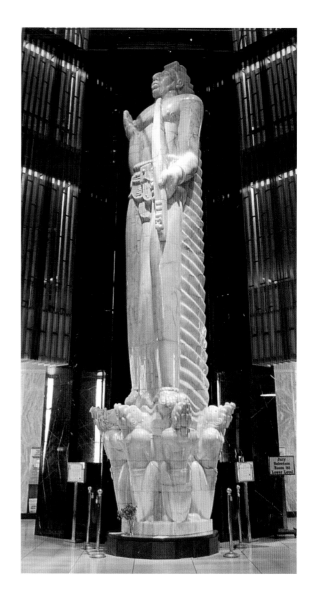

PREVIOUS PAGES, LEFT TO RIGHT *Father of Waters*, old Hennepin County Courthouse, Minneapolis; eagle, Wilkin County Courthouse, Breckenridge; Lady Justice, Brown County Courthouse, New Ulm; gargoyle, Freeborn County Courthouse, Albert Lea

think in the end the right design was chosen. Milles' first design, the apostle *Paul*, was bordering on scrawny and looked slightly inebriated. The second design was an emaciated *Father of Waters*. The third design, *Doughboy*, was a thin, stark nude, representing a returning World War I soldier. When this statue was presented to a hundred mothers of veterans, they thought it was a "disgrace." They told Milles they wanted a real soldier covered with blood and weapons. Their reaction upset him and he left St. Paul; no one heard from him for months.

Then he returned with the final design, *God of Peace,* which was based on an "Indian ceremony" he had witnessed in Oklahoma in 1929.

A placard next to it reads: "This statue depicts five Native Americans in a spiritual ceremony with their sacred pipes, from the smoke arises a Vision of Peace. One hand of the statue holds the sacred pipe, the other extends in a gesture of friendship—symbolic of the idea that with meeting and understanding comes the hope for world peace."

I studied the statue. The sixty-ton figure is tucked in an alcove, but rotates slowly from side to side. When the *Vision of Peace* was rotated to his left, I snuck in behind him and noticed that a hieroglyphic design ran up his concave back-

side. The design was hard to see because it was in shadow, but I was able to make out men running with bows and arrows, and one man falling as if hit by an arrow.

I didn't know what to think. The *Vision of Peace* appeared to have a warlike pictogram on his back. How had this happened? After much digging, I found a couple nuggets of information: "very little mention is made of some 25 figures sculpted into the onyx from the base up to the head. These are figures of Indians in various positions of archery, some 6 or 7 inches overall length, in clusters of 4, 5 or 6 braves." On a handout, the design is described as "stick figures resembling the painting on a hide of a buffalo hunt by Plains Indians." Not completely satisfactory. I will always wonder what Milles had in mind when he sculpted this design on the back of his statue.

Public comment about the newly unveiled piece was not particularly positive, especially from St. Paulites: "I get so damn mad everytime I see the thing, I can hardly talk." "Hideous in appearance." "Monstrosity, a huge joke." However, visitors from around the world loved it and Carl Milles was awarded a gold medal for his "great contribution for sculpture" by the Architectural League of New York.

LEFT *Vision of Peace* in the lobby of the Ramsey County Courthouse, St. Paul

LADY JUSTICE OR THEMIS

The favorite of all the statuary figures that adorn Minnesota courthouses is Themis, or "Lady Justice." In Greek mythology, she was the daughter of Uranus and Gaea, and also the goddess of law and justice.

Because she could foretell the future, in ancient times she was not represented blindfolded. Also, she usually carried no sword as it was felt she ruled by common consent, not force. But, on Minnesota courthouses, she is most often shown blindfolded and toting a sword and scales.

Courthouses that have Lady Justice in some form include Beltrami, Blue Earth, Brown, Cottonwood, Jackson, Le Sueur, Olmsted, Pipestone, and Steele.

She is often found poised on the very tiptop of the building and in this position becomes victim to all sorts of bad weather, sometimes even acting as a lightning rod. On the Cottonwood County Courthouse, she was made of sheet metal by W. H. Mullins Company: "Made of sheet bronze, copper and zinc, Mullins statues were lighter, sharper in design, easier to produce and cheaper than their stone counter-

parts. . . . Themis was purchased for the sum of $350 and placed upon the dome in 1905. The Goddess of Justice is approximately twelve feet high and weighs about 200 pounds."

The Cottonwood Lady Justice was struck by lightning once in 1908. The dome was possibly hit again in the 1930s, early in the 1960s, and once again in 1969. Then in 1996 seventy-five mile an hour winds toppled Themis. She was saved by the lightning rod cable to which she was tethered. "Her elbow and sword were broken and the body was bent." After extensive

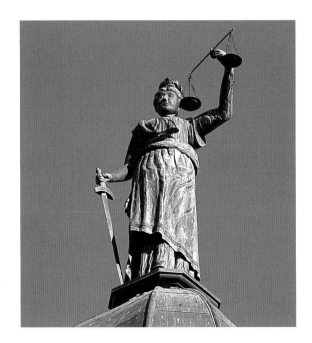

ABOVE Lady Justice atop the tower of the Blue Earth County Courthouse, Mankato

RIGHT, TOP Jackson County Courthouse tower and Lady Justice, Jackson, 1909, Beaux Arts, National Register (1977)

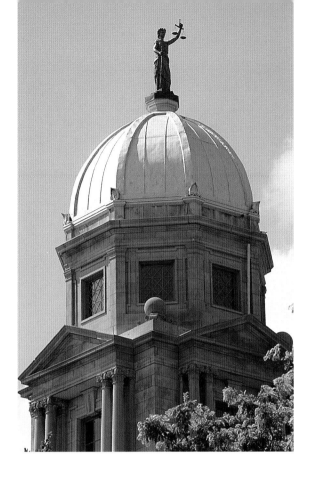

her "proper condition and grandeur," then hoisted back atop the courthouse with much of the town watching.

When the new county courthouse was built in Olmsted County, Lady Justice was removed from the old building before it was destroyed in 1957. She was to be housed in a niche built for her on the exterior of the new courthouse, but she was in such bad shape—dented, and missing her scales—that they stuck her in a storage yard at the highway department. This story does have a happy ending, however. She now holds court on the fifth-floor landing in the new building.

repairs, she was finally hoisted to the top of the dome in June 1998.

In Brown County the tower Lady Justice was standing upon was torn down. She was installed in a niche in a new gable in 1930. In Le Sueur County her tower was made one story shorter so her view changed.

When the Blue Earth County Courthouse dome was restored in 1991, Lady Justice—along with the dome—was lowered to the ground. One hundred and four years old, she was restored to

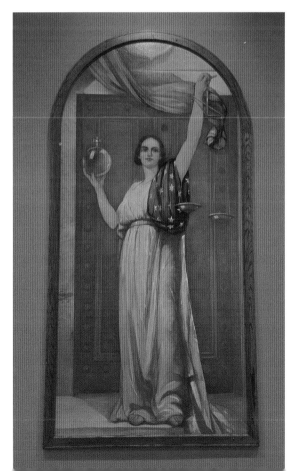

RIGHT Lady Justice in the courtroom of the Brown County Courthouse, New Ulm, 1891, German Renaissance Revival

In 1996, when Jackson County was completely restoring their courthouse, they painted Lady Justice gold and fashioned her a new sword.

In Steele County, Lady Justice was given some friends: Mercy and Law. Mercy is standing high in a niche, with Law sitting below her, holding a stone tablet, presumably the Ten Commandments. Justice is sitting nearby blindfolded, holding her hand up in the air, but missing her scales.

▨ ▨ ▨

Another notable statue that guards a courthouse is a sculpture of John Johnson at the Nicollet County Courthouse. Johnson was born near St. Peter and for many years edited the *St. Peter Herald*, before being elected governor of Minnesota in 1904. He served three terms. The statue is a replica of one at the State Capitol and was made by the original designer, Andrew O'Connor, in Paris. The bronze statue, weighing "in the neighborhood of three tons," stands on a pedestal "hewn from St. Cloud granite."

Many war memorials stand near courthouses in our state. In Pipestone, sculptor L. H. Moore offered to carve "a soldiers' monument, which would contain the "names of all the old soldiers both living and dead, in this county. . . ."

In Redwood County the army donated a cannon with a stack of 125 balls. "The cannon balls were implements of pranks for more than a half century. The last were hauled away in 1962. . . ."

In front of the St. Louis County–Duluth Courthouse is Cass Gilbert's Soldiers and Sailors Monument, *designed by him in 1921.*

CLOCK TOWERS

Let's go back to the old Hennepin County Courthouse for a moment as it has the largest clock tower in the state. This is a four-sided clock, 345

ABOVE Monument to commemorate an outstanding Native American, Cass County attorney Edward L. Rogers, in front of the Cass County Courthouse, Walker

feet tall, with each face four inches larger in diameter than Big Ben, London's famous clock. For nearly twenty-five years, this clock tower was the tallest structure in Minneapolis.

Clock towers are a feature of many courthouses, both past and present: Blue Earth, Hennepin, Martin, Morrison, Murray, Norman, Rice, Roseau, Swift, and Waseca counties. The original county courthouses of Kandiyohi and Polk had clock towers. Freeborn and Lyon's courthouses once had clock towers until the entire towers were removed.

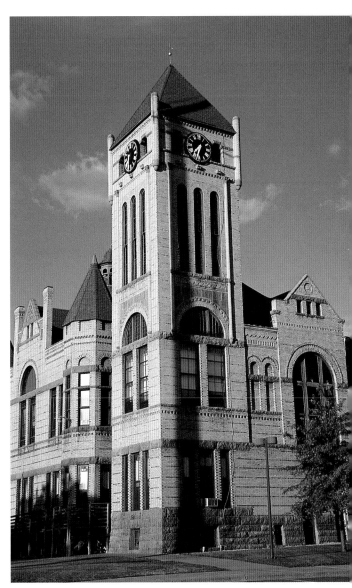

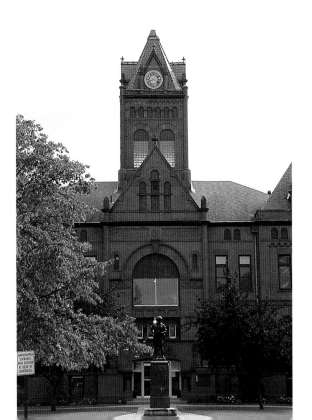

LEFT **Norman County Courthouse, Ada**

ABOVE **Morrison County Courthouse, Little Falls, 1891, Romanesque Revival, National Register (1978)**

One of the most unusual forms of court-house timekeeping can be found in Rice County. The bar association there was willed money from the estate of attorney Charles Nehemiah Sayles, who wanted the citizenry of the county to be made more aware of time through the use of a sundial. The architect William Broderson designed the dial and Kurt Kowatsch, a metal craftsman, built it. Broderson said of their partnership, "the sharp separation between architect and builder . . . was dissolved. . . . The end result was always in mind."

The brass sundial is a type called a vertical direct south dial, which means the sundial actually sits on the side of the building. The numerals were kept in the Deco style of the building and positioned to record Central Standard Time. Broderson explained, "This is because Minnesota has its best sun in the winter when we are using standard time."

The Murray County Courthouse, which was razed in 1981, had a clock tower that never housed a clock.

MURALS

Turn-of-the-twentieth-century courthouses were decorated not only on the outside, but inside as well: stained-glass windows, opulent domes, and impressive murals adorned their interiors.

Odin J. Oyen was responsible for many of the murals in Minnesota county courthouses. Born in 1865, he grew up in Wisconsin, went to school at the Art Institute of Chicago, and then formed an interior design firm in La Crosse, Wisconsin, "specializing in frescoes, painting, and paper hanging." He employed over forty workers and was well-known nationwide. Besides working on many courthouses in Minnesota, he worked on St. Joseph's Catholic Church in Minneapolis, and eight theaters in St. Paul.

Oyen designed murals for courthouses in Cottonwood, Grant, Jackson, Koochiching, and Lake counties.

As was true of much of the Victorian-influenced art, Oyen's work harkened back to Greek and Roman style. In the Cottonwood County Courthouse, the figures representing the various "Freedoms" are dressed in flowing robes and togas.

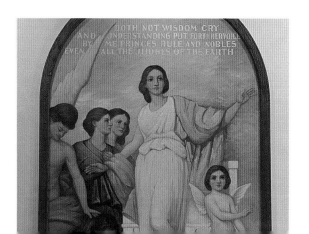

However, in the Koochiching County Courthouse built a few years later, his murals illustrate the county's history: the waterfalls of International Falls, the county seat; Alexander Baker, the first white settler in the county; a steamboat on Rainy River; and a sleigh of logs, representing the lumbering industry. The murals were designed by Oyen and painted by E. Sonderberg, also of La Crosse.

In 1975, when Don McNeill of Sioux Falls, South Dakota, was hired to renovate the Jackson County Courthouse murals, he noticed some oddities in the paintings. First, he decided that Oyen must have liked to paint plants and animals better than he liked to do people. He said the "detail in the leaves and flowers is much more than in the human figures."

Second, there's the matter of the naked breast. Originally, an angel in a panel depicting immortality was painted with a bared breast. Later, her clothes were "pulled up" to cover it. "One can only speculate on whether it was the artist's second thought that prompted it or an emergency meeting of the board of commissioners. The latter is more plausible. It is easy to envision five commissioners gathered in the rotunda, their hands behind their backs and their heads tilted upwards directing the artist to correct his 'mistake.'"

39

LEFT Mural in the courtroom of the Brown County Courthouse, New Ulm

ABOVE Courtroom and bench of the Jackson County Courthouse, Jackson

But the oddest features, and who knows if perhaps they were done to tweak these self-righteous commissioners, were some anachronisms in the paintings and the matter of the toes. In a dome mural that represents the arts and sciences, "toga-clad figures work in the foreground amidst classic columns while in the background a faint railroad track passes a sodbuster's house." And two of the figures in the murals have the wrong number of toes on their feet: the figure of despair has only four toes, (possibly why he is so unhappy?) and a man with the plans of the courthouse in his hands is shown with six toes on his left foot.

Very recently, these murals have caused more concern as a renovation of the courthouse was under way. Wold Architects wrote the State Historic Architect asking what to do with the required sprinkler system: "Not only will the fire protection system deter the visual beauty of the murals, there have also been occurrences on other buildings of leaking or broken sprinkler heads. . . . In order to minimize the risk of water damage to the murals, we are applying for a variance. . . ."

The State Architect, Charles Nelson, knows this building well and considers the murals, "among the finest to be found in the Classic Style public building of our state." He writes in

his letter back to Wold, "I feel that it is imperative to consider the Jackson courthouse murals works of art, rather than merely as decorations."

The Martin County Courthouse has several murals, including *Peace, War, Inspiration, Genius, Sentence,* and *Execution.* In a pamphlet prepared for the dedication of the courthouse, a section of the *Peace* mural is described: "The Indian in his typical paraphernalia, is eagerly watching the rapidly changing condition of the county, holding in his hand the plans of the new Court House, thinking of the times when only dense forests and prairie covered the land."

In 2001, the people of Breckenridge were trying to get information on the artist who might have done their four murals, "a Sioux brave astride his pony; then a steamboat in the river with Indian village in the background; third, a famoux Red River Ox Cart going across the long grass of the prairie; and fourth, a sod house of the first farmer. . . ."

Murals in the Stearns County Courthouse were done by St. Paul artist Elsa Jemne and depicted early Minnesota life. Four murals in the Ramsey County Courthouse were done by John Norton of Chicago. The paintings were described in the *Pioneer Press* as important figures in St. Paul's transportation industry: " . . . the pioneer, the voyageur with his canoe

paddle; the steamship captain; the railroad surveyor of yesterday, and next to him the skilled controller of rail transportation today. . . .”

DETAILS

All considerations were given to the minutest details of these well-loved buildings. Stillwater's old county courthouse had tile shipped in from England, but no one could figure out how to lay it. “Local workers could not solve the jigsaw pattern of the tiles, but William Willim, local contractor, solved the problem just as May was about to send for a specialist from New York.” Multitalented Willim was a plasterer and stone-

mason, also former Stillwater mayor and Washington County coroner. The courthouse was due to open for the 1869 fall session, but was delayed as it took Willim months to sort out the tiles and lay them.

⊠ ⊠ ⊠

Even the window shades for these buildings were given careful consideration. The Lincoln County Board of Commissioners met on May 11th in 1921 and considered eight possibilities as to how to cover their windows. They finally chose a bid that, at $860, came in right at the middle for canvas shades, two shades to a window, for seventy-seven windows.

⊠ ⊠ ⊠

The Otter Tail County Courthouse doorknobs are miniature works of art and were designed and commissioned by the architects, Buechner and Orth. Made by the Sargent Lock Company when the courthouse was built in 1920, they feature, not surprisingly, the curving figure of an otter on the head of the brass knob, and the escutcheon (keyhole plate) has the letters “OTC” engraved on it. ⊠

ABOVE Stearns County Courthouse, St. Cloud, 1922, Beaux Arts, National Register (1982)

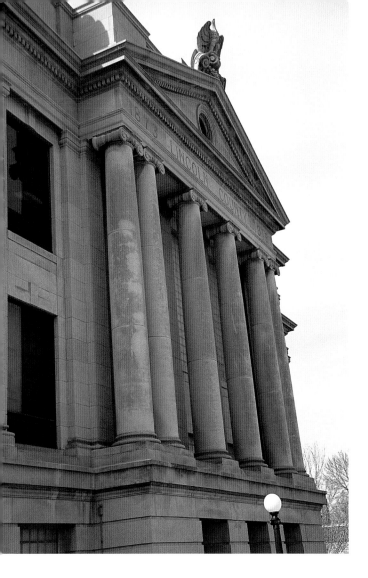

LEFT Lincoln County Courthouse, Ivanhoe, 1919, Beaux Arts,
National Register (1980)

BELOW Eagle above the main entrance of the Wilkin
County Courthouse, Breckenridge

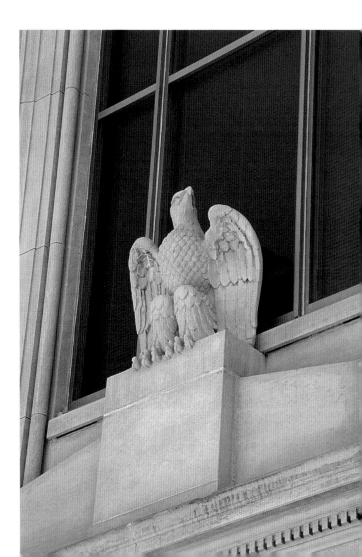

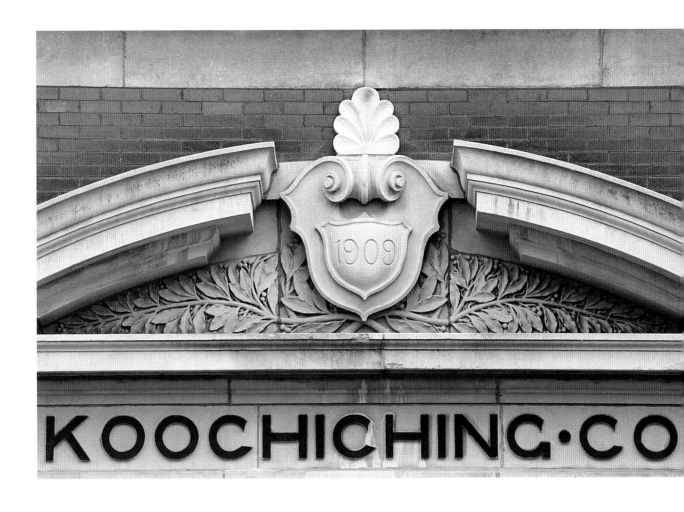

KOOCHICHING·CO

ABOVE Detail above the main entrance of the Koochiching County Courthouse, International Falls

NEXT PAGES, LEFT Blue Earth County Courthouse tower, Mankato, 1889, Renaissance Revival, National Register (1980)

NEXT PAGES, RIGHT View from the new Hennepin County Government Center (Minneapolis, 1974) to the old County Courthouse and City Hall (Minneapolis, 1889–1905, Richardsonian Romanesque, National Register: 1974)

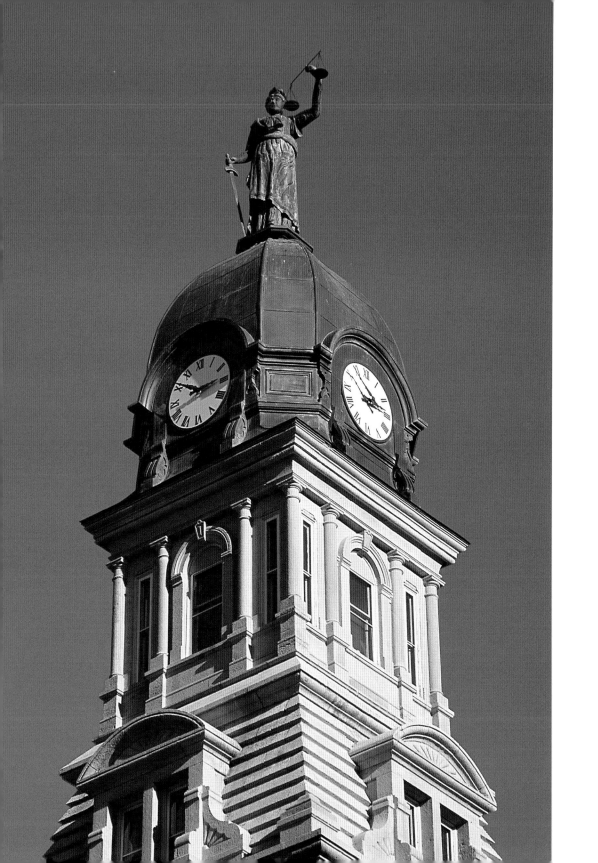

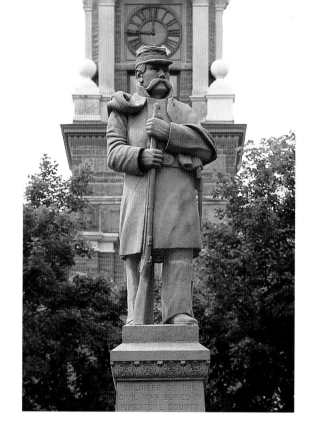

RIGHT Civil and Spanish American War monument in front of the Pipestone County Courthouse, Pipestone

BELOW Pipestone County Courthouse, Pipestone, 1900, Renaissance Revival/Beaux Arts, National Register (1980)

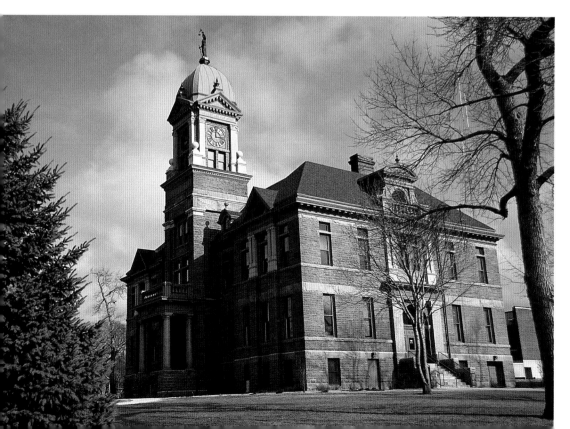

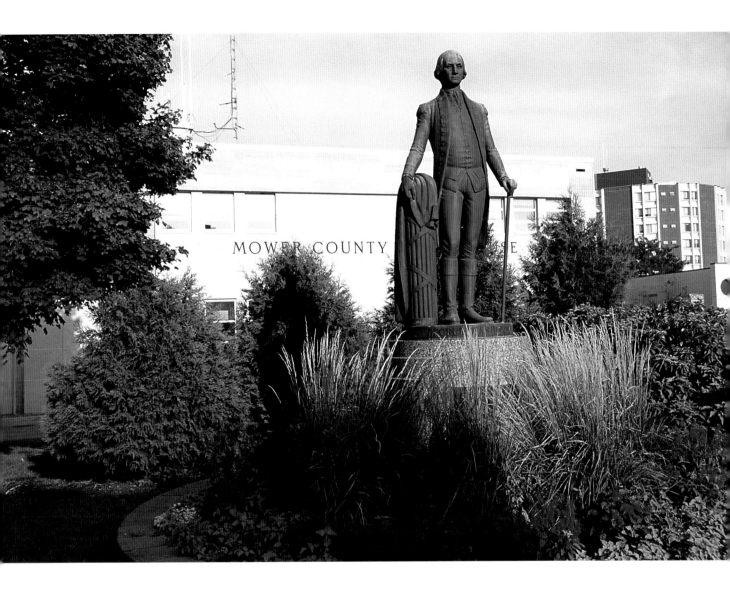

ABOVE Monument of President George Washington in front of the Mower County Courthouse, Austin

NEXT PAGES, LEFT Rotunda in the Jackson County Courthouse, Jackson

NEXT PAGES, RIGHT *Father of Waters,* old Hennepin County Courthouse and City Hall, Minneapolis

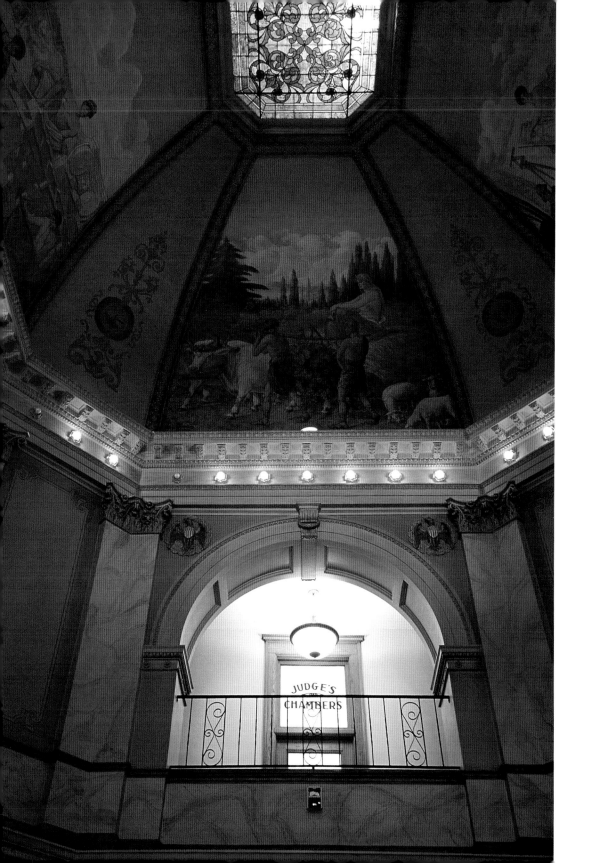

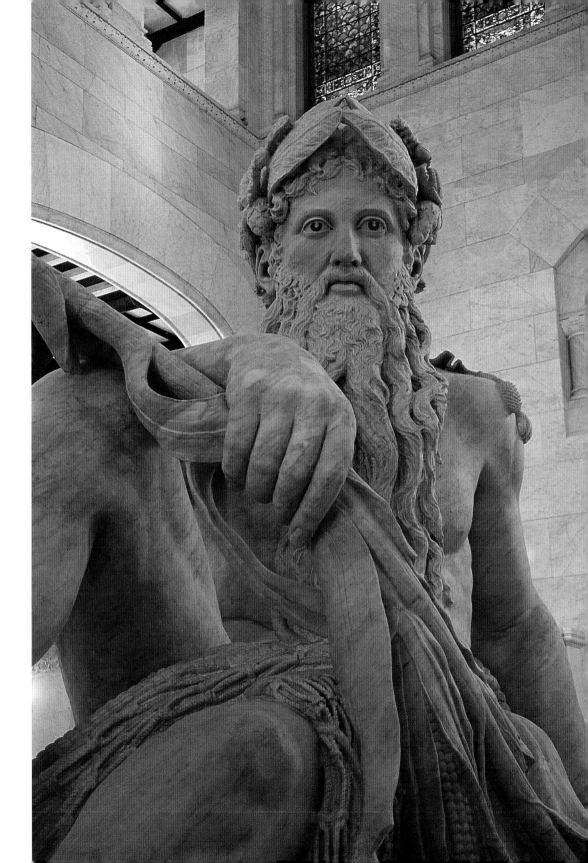

CHECKING THE RECORDS

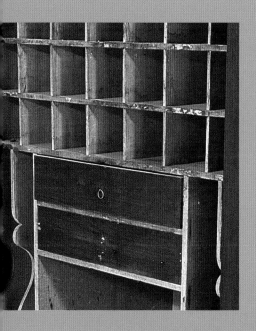

IN 1993 *I walked into the Stevens County Courthouse in Morris, Minnesota, and asked to see the death certificate of my great-grandmother, Honora "Nan" McNally. I was working on a book about her daughter, my grandmother Mary McNally Kirwin, which would be called* Halfway Home. *The county recorder escorted me to a shelf of black folders and pulled out the folder for the year 1916. I still remember looking through all the recorded deaths for the year she died until I found hers in Death Record "C," page 81, Section 22. ¶ Somehow reading the actual yellowing document made her passing more real and very poignant. In a spidery scrawl, someone had written down her cause of death as "acute articulate Rheumatism." I wanted to reach back all those years and ask what really happened. I wanted* ☞

and marriage certificates—were kept by the churches.

COUNTY RECORDER

In our country, the repository of such information has become the county courthouse. The county recorder, besides keeping track of the birth, death, and marriage records, also holds "all records relating to deeds, mortgages, transfers and contracts affecting lands within the county."

Neoma Laken, Wilkin County Recorder and Registrar of Titles, explains what the county recorder's office does in a 1978 memo:

> *In our Real Estate Property Division, we record deeds, mortgages, contracts for deed, satisfactions, mechanic's liens and releases of same, probate and guardianship papers, affidavits, death certificates, leases, easements, foreclosures, official bonds, township treasurer's bonds, powers of attorney, articles of incorporation, partnership agreements, federal tax liens and releases, and military service discharges.*

to know why a woman in her mid-forties makes dinner for her family, feels sickly and tired, and dies before the day is over, leaving behind a husband, four daughters, and a son. Four children had preceded her in death.

But I am thankful for the information I received in care of this courthouse. The county recorder gave me a certificate of her death record, which I have kept, stating that Honora McNally, born March 5, 1872, died just over forty-four years later on March 11, 1916.

My ancestors were from Ireland and in that country, as in much of Europe, most of the records regarding people—birth, death,

But my favorite phrase that Laken uses in describing what her office does is the "Chattel Security Department." I think the only other place I've ever read the word "chattel" is in the Bible. In our country, this keeping track of everything is a very important, almost holy, obligation.

PREVIOUS PAGES, LEFT TO RIGHT Polk County Courthouse, Crookston; original doors, old Sibley County Courthouse, Henderson; Olmsted County Government Center, Rochester; desk, Sibley County Courthouse

ABOVE Latest Stevens County Courthouse, Morris, 1956, International Style

can walk into any county courthouse in the state and get a copy of your birth certificate, whereas before this was only possible at your county of birth.

Long before there were courthouses, there were records. In Douglas County the records were kept in the homes of the appointed officials until a building was leased to serve as a courthouse in 1867. In the early days, Norman County "had no money for a courthouse. For some years the records of the different officials were so few they carried them back and forth to their homes."

According to the county recorder in Wabasha, he is also in charge of notary commissions, driver's license renewals, and ordination records, and acts as a passport agent. He explained to me that they received birth certificates from the area hospitals and death certificates from the funeral directors. In Minnesota there is a five-day waiting period after the issuance of a marriage license and the officiating person must send in the marriage notice to the county within five days of the ceremony.

Much of this has changed since the state of Minnesota went electronic in 2000. Now you

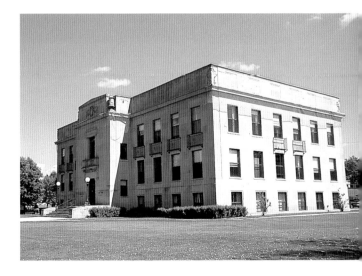

ABOVE, LEFT Old county clerk's desk found in the basement of the original Sibley County Courthouse, Henderson

ABOVE, RIGHT Mille Lacs County Courthouse, Milaca, 1923, Renaissance Revival, National Register (1977)

RECORDS SURVEY

In 1940 the Minnesota Historical Records Survey Project took place, part of the Works Progress Administration (WPA). Workers traveled across the state, archiving what the many counties had in their possession. This information was written up in an "Inventory of the County Archives of Minnesota." The various counties were given different numbers and were measured and catalogued and inventoried and scrutinized. One of the sections in their reports is called: "Housing, Care, and Accessibility of the Records." Let's just peek into the office of the register of deeds in Rock County in July of 1940:

The office of the register of deeds is 23 x 15 ½ feet. Records are kept here only temporarily. The register's vault is 13 x 23 feet with double steel doors and two windows with steel shutters and wire mesh in the glazing. . . . The only hazard to the records is a radiator and pipes in the vault. Temperature of the air is medium, and there is no dust or dampness. The place is not crowded, and there is space for more shelves. . . . The windows are shuttered, and the door is locked when the office is not in use.

Or in Beltrami County: "The records are crowded but easily accessible and there are good accommodations for users."

❖ ❖ ❖

There are probably many things to brag about when you are writing the history of a county, and in 1916 William Gresham chose to be impressed with the record keeping of Le Sueur County:

The vaults in this splendid building are of the best and the books and papers will there be safe and well preserved as the decades come and go. Each officer vies with his fellow officers in keeping his books and papers in proper order and where they may be referred to at any time with ease. The state inspectors compliment the present officers and the manner in which they conduct the business and care for legal papers and county books, stating that few counties, if any, in Minnesota, have a better-kept business than the LeSueur people have.

FAMILY HISTORIES

County records are essential in genealogical research and, as the baby boomers age, interest in this field has flourished. The records most helpful in this type of research are birth, death, and marriage records. Genealogy researchers sometimes find out more about their ancestors than they wanted to know.

But another group of people scour the records for traces of their families with more trepidation: adopted children. In Minnesota, when an adopted adult requests a copy of an original birth certificate, the birth parents are located and asked to consent to this request. If they cannot be located or do not respond to the request, the adoptee can have the information if they were adopted after August 1, 1977. If the adoption took place prior to this date, then they must petition the court for their records. Otherwise, all birth records are private for one hundred years.

In his book, *Prairie Son,* author Dennis Clausen recreates the story of his father's search for his birth parents. This search leads Lloyd Clausen to the Lac Qui Parle County Courthouse in the early 1940s. He has found a hidden piece of paper with the name Edward Mosen written on it and is convinced that this is his birth name. He asks at the county recorder's office for the birth certificate of Edward Mosen. The woman he talks to checks the records but tells him she can find no such name.

Disappointed he turns away. She stops him, asking him if he's sure he spelled the name correctly. She explains that while she's never heard of anyone "from these parts" with that last name, she knows there are many people in the county with the name "Moseng."

When she checks for that birth certificate, she returns and asks him, "Was there an adoption involved in that birth?" In the end, she tells him she's sorry, those records are sealed, but, in her own roundabout way, she has given him the information he needs. ▧

Fillmore County Courthouse, Preston, 1958

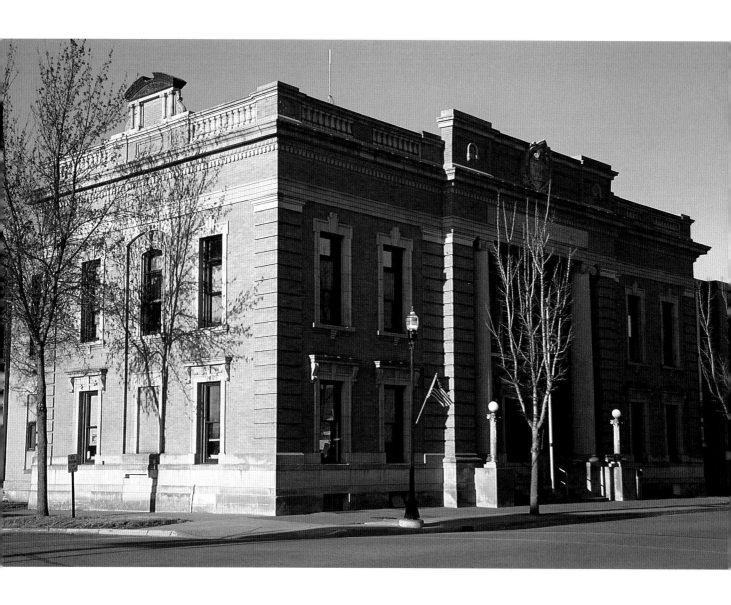

ABOVE McLeod County Courthouse, Glencoe, 1909, Beaux Arts, National Register (1984)

Koochiching County Courthouse, International Falls, 1910, Renaissance Revival/Beaux Arts, National Register (1977)

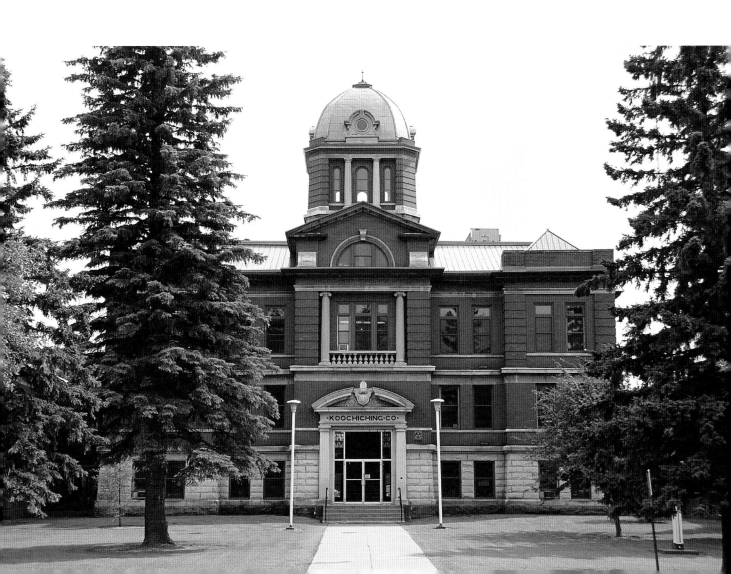

BELOW Clearwater County Courthouse, Bagley, 1937, Art Deco

RIGHT Corridor in the Olmsted County Government Center, Rochester, 1993

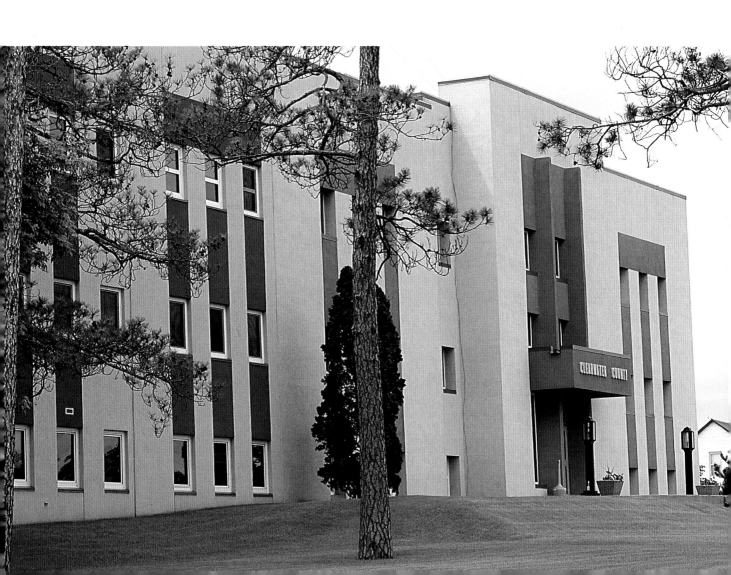

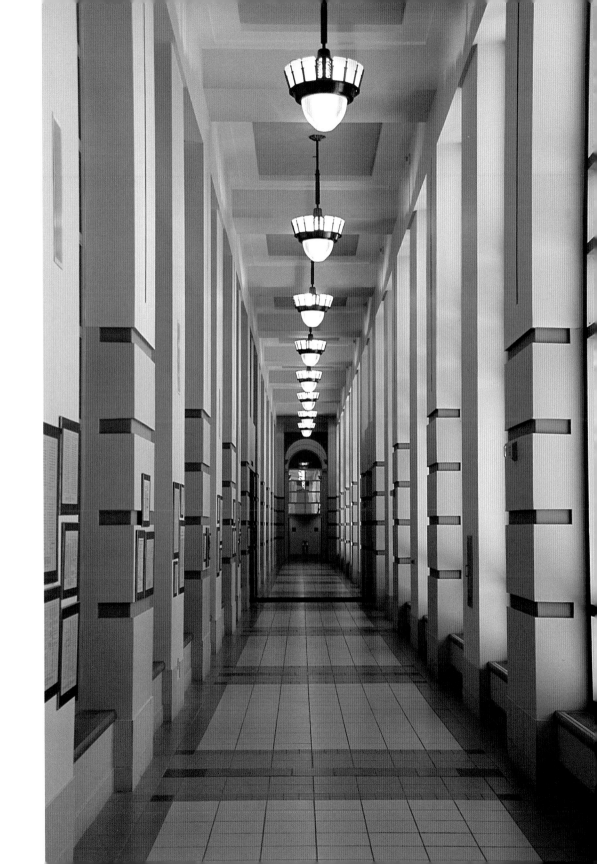

PREVIOUS PAGES Polk County Courthouse, Crookston, 1968

BELOW Otter Tail County Courthouse, Fergus Falls, 1922, Beaux Arts, National Register (1984)

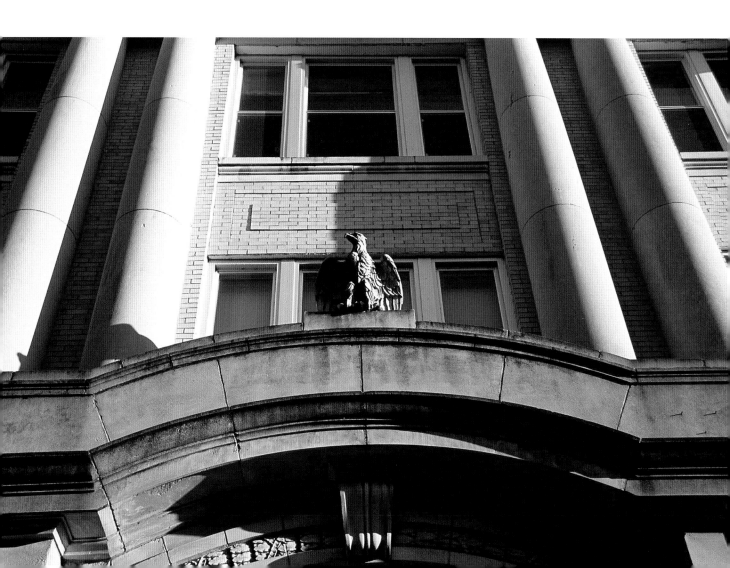

ABOVE Pope County Courthouse, Glenwood, 1930, Classical Revival, National Register (1982)

TRIALS & TRIBULATIONS

IN MY EARLY THIRTIES *I spent a riveting morning in a Washington County courtroom. Judge Esther Tomljanovich, a former neighbor, had invited me to lunch, and I went early to watch her "hold court." ¶ I quietly slid into a long wooden bench at the back of the dark, paneled courtroom, not wanting to disturb the lawyer arguing his case. After sitting there for a couple hours, I came to understand how courtroom cases had been a major source of community entertainment before the advent of television. I even recognized one defendant. He had lived up the street from me when I was a kid and now was on trial for drug dealing. ¶ A small woman, Judge Tomljanovich appeared larger than life in her robes, seated up high on her bench. Everyone deferred to her in the most reverential way. The defendants* ☞

acted as if she were a parent meting out the punishment for their latest indiscretion. They would stand below her and talk directly to her, begging, promising, even crying. Then she would decide. I was surprised how intimate and personal an interaction the trials were, how much power she had in her decision-making process.

But what I really loved was that everyone called her "Your Honor." I thought that appellation had the most noble ring. I found out that you could become a judge without going to law school and, for the rest of the afternoon, I thought that might be a job worth looking into.

However, I went on to publish mysteries, and Esther Tomljanovich became a Minnesota Supreme Court Justice, the second woman to receive such an honor.

LAW OF THE LAND

Many things happen under the roof of the courthouse, but the main function of this building is to uphold the law of the land. In 1983 the president of the Minnesota State Bar Association wrote, "The quiet acceptance by Minnesota citizens of a rule of law and their devotion to it has made possible a productive and ordered society new to this geographical area. . . . Arguments, disputes, and disagreements do and

have existed and are resolved within the framework of fairness and equality."

The county courts have five court divisions: civil, criminal, family, probate, and conciliation, and judges are elected for six-year terms without party designation. The more important cases—felony cases and civil suits involving more than $5000—are held in the judicial district courts, which are also housed in the county courthouses. The judges for these courts are elected in the same manner as county court judges.

In 1855 the first jury list for Wright County was selected by the commissioners. "Of the 38 names on the grand jury list, not one was a woman, not one was black, not one was an Indian and not one was a hired man." Each year the county selected a new list of landowners to sit and hear cases brought before the district judges. If a man couldn't make it because he had too much work at home, the sheriff was sent out to fetch him and was paid a few dollars for his time. "When a man of Wright County came to trial, he was indeed tried by a jury of his peers."

COURTROOMS

In the early years of the original Washington County Courthouse the large courtroom on the

PREVIOUS PAGES, LEFT TO RIGHT Law books, Wright County Courthouse, Buffalo; historic Washington County Courthouse, Stillwater; lobby, Carlton County Courthouse, Carlton; courtroom, Jackson County Courthouse, Jackson

second floor of the building was in constant use with the wranglings of "lumbermen and riverboaters, who fought legal battles over the use of the river."

When the Mille Lacs County Courthouse was being finished in the early 1920s, a reporter for the paper was impressed with the layout of the jury room:

> *An especially interesting feature is the provision made for the jury. The jury can retire from the court room direct to the conference room without entering the main corridor. The quarters for the jury provides separate toilet rooms and sleeping rooms for the men and women jurors. When the jury is locked up, there is no possibility of their being approached by outsiders.*

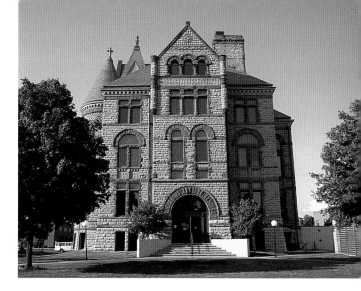

The courtrooms were often quite luxurious, decorated with chandeliers, lovely wooden benches, and beautiful woodwork. In the Watonwan courtrooms, "theatre style seats across the large room housed the public that turned out for most court trials of note."

While many love the grandeur of the old courthouse rooms, not all attorneys liked to work in them. When the Winona County Board was trying to decide if they would repair their old building or build a new one in 2001, after extensive water damage, a county attorney argued that the courthouse, "was a miserable place to try a case." He complained that security was a problem, some of the rooms were cramped and many were not handicap accessible, and "rape victims sometimes have to sit in the same hall with accused rapists."

These beautiful old rooms were not always up to the task of being a workable courtroom.

67

ABOVE, LEFT Wright County Courthouse, Buffalo, 1959

ABOVE, RIGHT Winona County Courthouse, Winona, 1889, Richardsonian Romanesque

In trying to redo the rooms with better lighting and air conditioning, the situation was often made worse. Before Rock County renovated its old courthouse, this is the scene in its main courtroom:

A few years ago, the old blue courtoom might have been the setting for scenes from a seedy Southern movie. It was enormous, occupying most of the entire top floor. It was lighted by dangling 50s-style fluorescent light fixtures and had creaky doors and floors and a noisy window air conditioner or sweltering heat in the summer or bone-chilling cold in the winter. The open judge's chambers in the old courtroom also enabled the public to hear every word uttered in the privacy of the judge's chambers.

In Watonwan County, there was a report of impropriety. When a bailiff grew tired of waiting for the jury to return a verdict, he piled chairs up in the front of the door and looked over the transom to see what was keeping them. "The gentleman baliff was retired with thanks the following day."

FAMOUS CASES

In Hennepin County several well-known cases were held in the old county courthouse including: the case of Kate Noonan, who killed Will Sidle on Nicollet Avenue and was acquitted; Ignatius Donnelly's case against the *Pioneer*

ABOVE, LEFT Wooden model of the Watonwan County Courthouse, St. James, 1896, Romanesque Revival

ABOVE, RIGHT Wood carving behind the judge's bench in the Wilkin County Courthouse, Breckenridge, 1928–29, Beaux Arts/Moderne

Press for libel in which he was awarded a dollar for his troubles, and the case of the Barrett Brothers, who were convicted there of killing a streetcar motorman on Lake Street and Cedar Avenue—they were both hanged.

Some recent important trials held in county courthouses in the last several decades include: the early 1960s murder trial of T. Eugene Thompson, which was moved from Ramsey

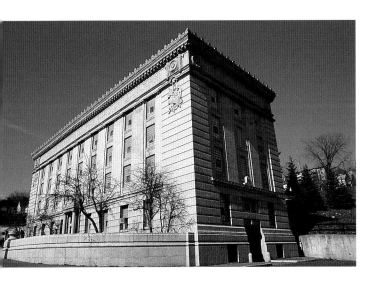

County to Hennepin County on appeal and was one of the first trials in which the court transcript was printed in the daily paper; the Roger Caldwell–Congdon murder trial held in Crow Wing County in 1978; the Marjorie

Caldwell–Congdon murder trial held in Dakota County in 1979; the Jordan child sex-abuse trial held in Scott County in 1984; and the Sharon Bloom murder trial which was held in Rice County in 2000.

⊠　⊠　⊠

In an essay on the Watonwan County Courthouse a scene in a murder trial is described:

> *The verdict was returned at about two o'clock in the morning and the courtroom was shadowed and austere where the chandelier light did not reach. A storm was moving across the sky and lightning flashed across the window to the west. Just as the Clerk read the words, "We find the defendant guilty as charged," a mighty flash of lightning and thunderous roll of thunder sealed the words.*

JAILS

The sheriff's department and the jail were often located in the courthouse or right next door in order to move the prisoners easily into and out of the courtrooms. Often this building was in a matching style to the courthouse and found on the same square.

In 1902 Beltrami County was voting on whether to build a new jail and courthouse. A reporter for the *Bemidji Pioneer* thought it was about time:

69

ABOVE St. Louis County Jail, Duluth, 1909–29, Beaux Arts. The jail closed in 1995.

The courthouse should have been built years ago, and a larger jail should have been built instead of the one we now have. When Christianity reaches its highest development, the present jail may be large enough for the needs of the county, but at present it is not half so. Business sense demands a larger jail at once.

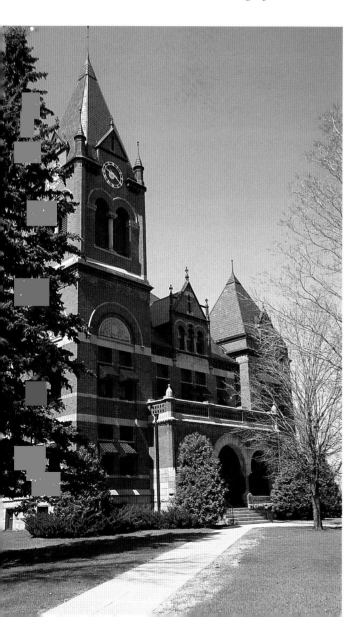

As it cost a county money to board its prisoners elsewhere, it made economic sense to be able to put them up in their own jail. It also saved time for the sheriff and his deputies. The Swift County sheriff was happy to see the completion of a new law enforcement center behind the courthouse in Benson, "It seems like all we're doing is transporting prisoners." They even waited to apprehend suspects if they didn't have the jail space, but not for serious crimes.

In Todd County the jail was so rundown, the inmates sued the county "because of poor living conditions." The court decided a prisoner couldn't be held in the jail for longer than twenty-four hours. This also happened in Hubbard County: "The death knell for this building was dealt when an individual was incarcerated and he moved directly toward getting it condemned. The building was declared unsafe due to broken windows, poor mortar joints, poor heat, sanitary facilities which were very old and did not work well, and the Sheriff protected the outside with a watch dog."

Douglas County's 1880 jail was "damp and dark" and condemned by the State Board of Corrections and Charities in 1899.

The Washington County jail has held some famous prisoners including the Younger brothers, who robbed the Northfield bank with the

James brothers in 1876. A farmer was held there in the mid-1900s when he wouldn't let NSP workers erect a power pole on his property, holding them off with a rifle. He was released after accounts were published in the newspaper of his wife and children coming down to the jail to sing him Christmas carols.

⊠ ⊠ ⊠

In many of the jailhouses, the sheriff and his family also lived there, with the wife cooking for the inmates. Once, at the Washington County jail, the prisoners heard that the sheriff was going downtown and they planned to make a break. "The wife heard a commotion in the jail and met the prisoners at the door with a shotgun. She held them off until the sheriff returned to the jail."

In 1958 Neil Haugerud was elected sheriff of Fillmore County. He served in that position for nearly ten years and his wife and children lived in the jailhouse, which had been built in 1869. In *Jailhouse Stories: Memories of a Small-Town Sheriff,* he describes the jailhouse as

> *an unimposing, two-story brick building . . . situated on a tree-lined residential street in the town of Preston, nestled deep in the Root River Valley of central Fillmore County. . . . We boarded nine prisoners: three drunks,*

> *a check forger, a mental patient waiting hearing, and four small-time burglars, two of whom had previously broken jail. The burglars were locked in the upstairs bull pen. We had two bull pens, one on each floor. They were very secure lockups, with heavy steel bars located six feet from any exterior walls. Each had four separate cells, two bunks to a cell.*

His wife cooked meals for the prisoners and they used the dumbwaiter in their kitchen to send down the food and also to communicate with the inmates. Most of their prisoners were drunks, mentally unstable people, and small-time crooks. When they behaved, the prisoners helped out around the place: mowing the lawn, washing windows, sometimes even watching the children. Haugerud didn't believe in carrying a gun most of the time. He worried someone would get shot.

The old jailhouse in Fillmore County is now an inn. You have your choice of sleeping in the Detention Room, the Drunk Tank, or the Cell Block. ⊠

71

LEFT Swift County Courthouse, Benson, 1898, Victorian Romanesque, National Register (1977)

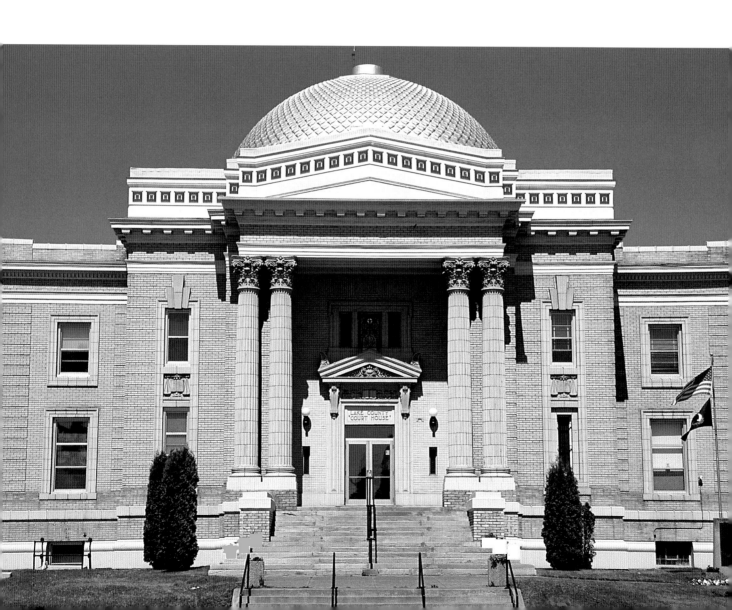

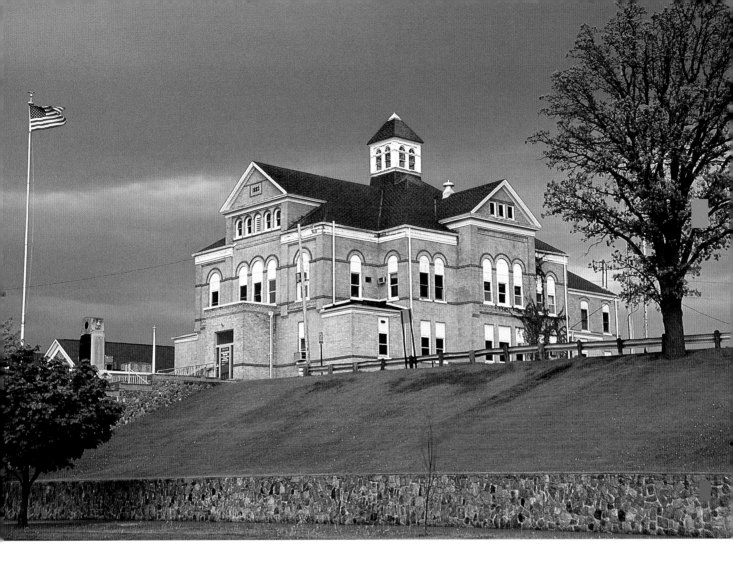

ABOVE Todd County Courthouse, Long Prairie, Romanesque Revival, 1883, National Register (1985)

NEXT PAGES Lac qui Parle County Courthouse, Madison, 1899, Romanesque Revival, National Register (1985)

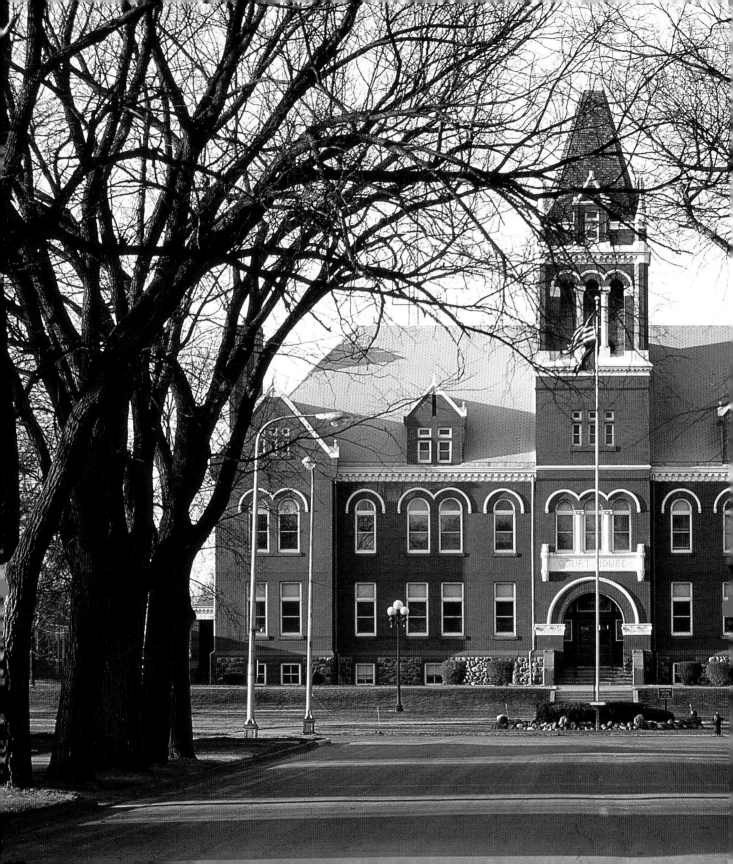

RIGHT Historic Isanti County Courthouse, Cambridge, 1887, vernacular French Second Empire/Italianate, National Register (1980)

BELOW New Isanti County Courthouse, Cambridge, 1996

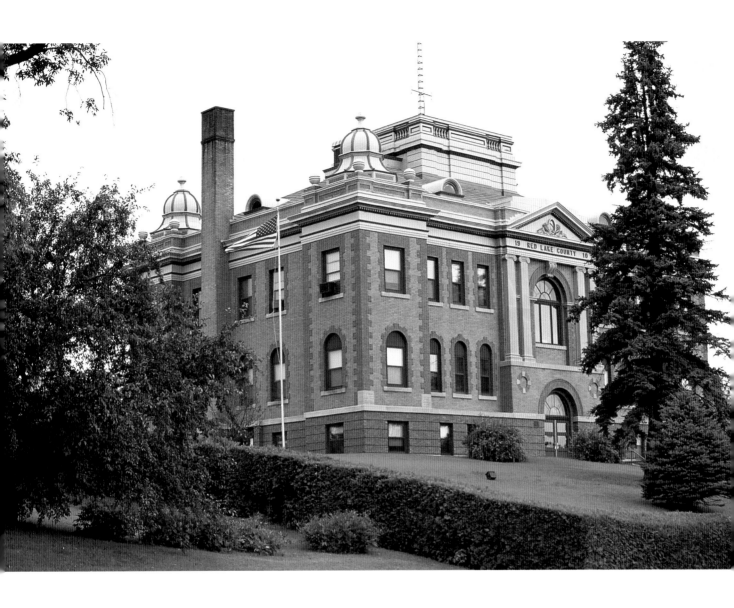

Red Lake County Courthouse, Red Lake Falls, 1911, Beaux Arts, National Register (1983)

BELOW Dome of the historic Washington County Courthouse, Stillwater

RIGHT Tower detail of the Winona County Courthouse, Winona

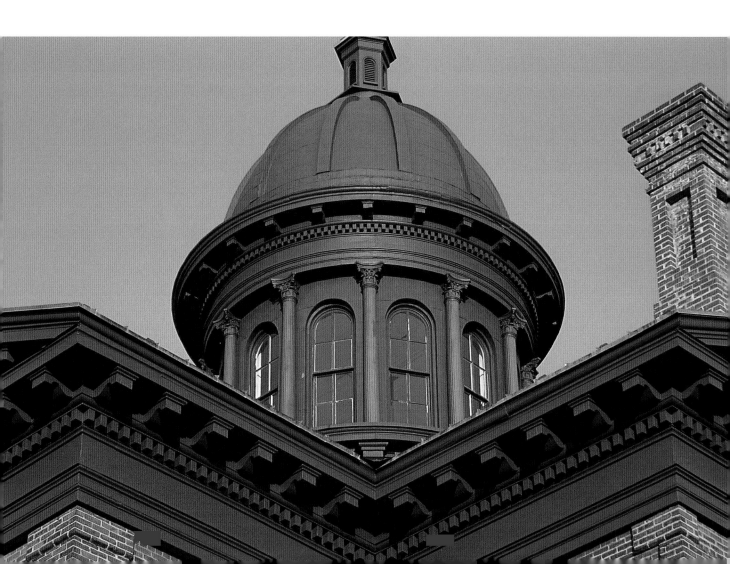

BELOW Dome of the historic Washington County Courthouse, Stillwater

RIGHT Tower detail of the Winona County Courthouse, Winona

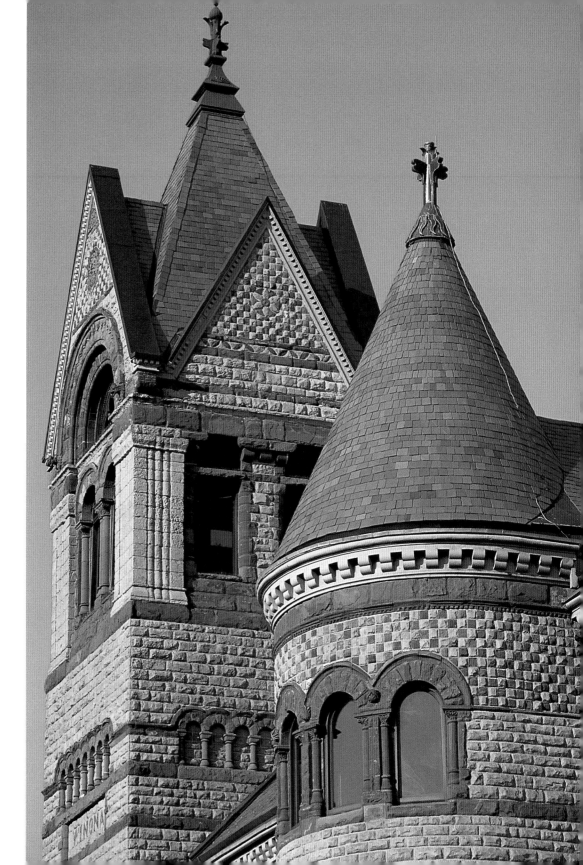

CONDEMNED TO DEATH

FOR THE FIRST *fifty-three years of Minnesota history, a decision in a courthouse could literally determine if someone would live or die. Even now, nearly a century after the abolition of the death penalty, lives can still be destroyed or redeemed in courtrooms around the state. ¶ Courtroom scenes remained distant and academic for me until I was personally involved in one. In the spring of 1980, I was called as a prosecution witness in a murder trial. I will admit quite candidly that I remember few details about this overwhelming event, but it left me with a deep and abiding faith in our judicial system. And an even larger awareness of the strength of the court. ¶ My sister was murdered in November of 1979. I helped with the police investigation and, about six months after her death, a suspect was*

arrested. A trial date was set. I have never believed in the death penalty, but I hoped that the suspect would be put away for, at least, the rest of my life.

My father also testified at the trial. What I do remember from this day is that he and I waited for endless hours in a small window-less room in the Hennepin County Government Center. To while away the time, my father told me stories about his few times serving on a jury. He went in first to testify. After he finished, I was put on the stand.

I don't remember what the room looked like. I vaguely remember the kindness of the prosecuting attorney as he explained to me what would happen. I'm not sure that I even

looked at the jury. What I do remember is that I wanted the members of the jury to see my sister as I had known her. I wanted them to understand that some punishment should be meted out to the man who had taken her life.

The defendant had confessed to my sister's murder: her clothes had been found in his girl-friend's apartment and he had pawned her tele-vision set. He was found guilty of third-degree murder and was sentenced to sixteen years in prison.

After the verdict, one of the detectives called me and said that the defendant had recanted his confession, claiming a friend of his had actually killed my sister. I could hardly breathe. I needed to get to the truth. I asked what we should do. The detective said my name, then said, "It's over. The jury has decided. He's going to jail." And in that moment, I saw that it was out of my hands. The state had decided.

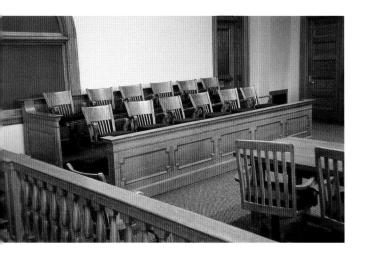

PREVIOUS PAGES, LEFT TO RIGHT Courtroom, Brown County Courthouse, New Ulm; jury chairs, Jackson County Courthouse, Jackson; Ramsey County Courthouse, St. Paul; judge's gavel, Becker County Courthouse, Detroit Lakes

DEATH BY HANGING

For nearly a century, Minnesota has had no death penalty. It is one of twelve states that does not allow it. The maximum penalty for first-degree murder is life in prison. But this was not always the case. From the time Minnesota became a state in 1858 until 1911, death by hanging was the maximum punishment in such cases.

The first person hanged in Minnesota and the only woman ever killed under its death penalty was Ann Bilansky. She married an older, rich man and moved her "nephew" John Walker into the house with them. Then her husband came down with an unexplained illness of nine-days duration and died. The cause of death was determined to be arsenic poisoning. Bilansky was found guilty of murder, but fought the conviction for a year.

On March 23, 1860, Ann Bilansky was hanged in St. Paul. "The custom in those days was to carry out the execution in the jail courtyard during the daylight hours. . . . [The] sheriff of Ramsey County had his gallows ready . . . a plain, black coffin lay at its foot." A crowd of between fifteen hundred and two thousand people watched from nearby streets and rooftops. Afterwards, spectators grabbed pieces of the rope for souvenirs.

▨ ▨ ▨

The first man legally executed in Minnesota was Henry Kreigler, born in Germany in 1825. He came to Freeborn County with his wife and stepson in 1858 and was found guilty of murdering his neighbor. "Different sources give the date of the hanging as February 26 and

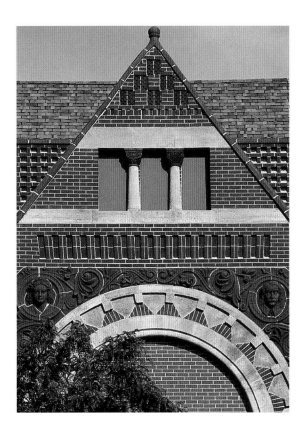

83

March 1, 1861. It took place south of the court-house in Albert Lea, and hundreds of spectators lined the hill to watch his death take place."

⊞ ⊞ ⊞

After the first hanging in St. Paul, there followed sixty-five more people put to death in this manner over the next forty-six years. Walter Trenerry, in his book *Murder in Minnesota*, cautions that this number is approximate. Since hangings took place in the counties of conviction and over the years records might have been lost, these are the hangings for which records still exist.

Single hangings took place in the following counties: Aitkin, Carver, Cass, Clay, Crow Wing, Douglas, Morrison, Pine, Redwood, St. Louis, Sherburne, Sibley, and Yellow Medicine. Four people were hung in Ramsey, also four in Hennepin County. St. Louis County was witness to two hangings (not counting the lynchings), as was Otter Tail County. This is not counting the mass hanging in Blue Earth County.

⊞ ⊞ ⊞

After the Sioux Uprising of 1861, a military commission tried 392 Sioux as "war criminals rather than honorable belligerents" in the first courthouse in Blue Earth County. The building was a one-story measuring 20 by 24 feet and was built in 1857.

Thirty-eight Native Americans were executed by "simultaneous hanging in December, 1862." For several years after that, Blue Earth County offered a bounty of $200 for the scalp of any Indian found within its borders.

⊞ ⊞ ⊞

The last person legally hanged in Minnesota was William Williams. Originally from Cornwall, he fell in love with a young man in St. Paul,

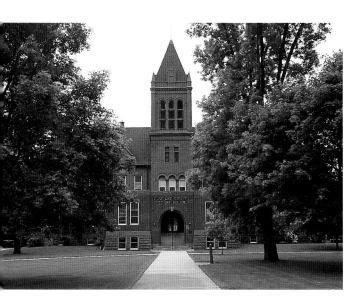

ABOVE Douglas County Courthouse, Alexandria, 1895, Romanesque Revival, National Register (1985)

Minnesota. After their two-year relationship got rocky, he killed the sixteen-year-old boy and his mother. In the spring of 1905 in the Ramsey County Courthouse, he was found guilty of murder in the first degree and was sentenced to be "hanged by the neck until dead."

He was hanged on February 13, 1906, still proclaiming his innocence. His execution by law had to take place before sunrise and "within a jail if possible, limiting the number of spectators."

The sheriff miscalculated the length of the rope and the poor man danced on his tiptoes when the rope stretched and allowed him to touch the floor. Three deputies seized the rope and pulled it up higher, holding it for fourteen and a half minutes until Williams choked to death.

Some of the local newspapers went into gory detail describing the bungled execution. Public sentiment on the death penalty had been turning anyway and this final, grotesque hanging cinched it. In 1911 the death penalty was abolished.

LYNCHINGS

There were twenty-two known lynchings in Minnesota. Lynchings took place in Becker, Brown, Crow Wing, Le Sueur, Wright, Blue Earth, St. Louis, and Hennepin counties.

The jail in Brainerd, the new county seat of Crow Wing County, was built around 1872, a two-story building with six jail cells on the first floor and a courtroom on the second. The jail

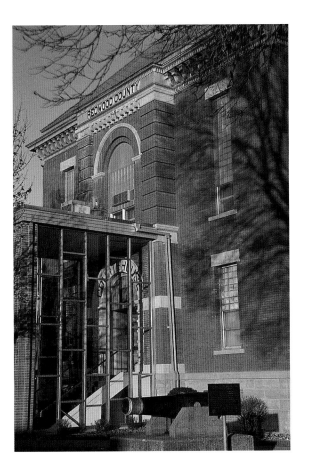

ABOVE Redwood County Courthouse, Redwood Falls, 1892, Romanesque Revival

walls were made by pounding "innumerable nails, making the wall solid as Gibraltar, and utterly impregnable to ordinary tools."

That same year, two Indians were taken into custody for the disappearance of a young white woman. They were each put in separate cells in the Crow Wing County jail and told that the other one had been "hanged by the citizens."

A couple weeks after they had been incarcerated and two days before their trial, on July 23, 1872, a mob broke into the jail and left with the two prisoners and dragged them to a tall pine tree by a saloon in town. Both men were hanged and left dangling in the tree for that day and the following night, then their bodies were spirited away and buried in secret.

⌗ ⌗ ⌗

In 1920 a circus came to Duluth and with it some black workers. A nineteen-year-old woman claimed that she and her boyfriend were held at gunpoint by six of them and then she was raped.

Six blacks were arrested and held in the Duluth city jail. That same night a mob of between a thousand and ten thousand people stormed the jail, took the prisoners, and held a mock trial. Three of the black men were beaten and then lynched, hung from a light

post. The next morning the Minnesota National Guard arrived and took the remaining three prisoners, along with other black circus workers, to the St. Louis County jail.

A grand jury was convened two days later. Twenty-five white men were indicted for rioting and twelve for first-degree murder. Eventually eight whites were tried, and only three were convicted of rioting. The three each spent only slightly more than a year in prison. None were found guilty of murder.

Seven blacks were indicted for the crime of rape. Only two were tried for the crime—one was acquitted and the other man was sentenced to serve seven to thirty years in prison. After four years in Stillwater Prison, he was released on the condition that he leave the state.

GHOSTS

If ghosts are unhappy spirits who have an ill-fated connection to a certain place, then it makes sense that some of the courthouses in our state would be haunted.

The basement staff lunchroom in the Ramsey County Courthouse is located where the gallows were for William Williams' hanging. Workers have reported seeing "a glimpse of a man dropping from the ceiling on the end of a noose as if coming from a trapdoor."

This courthouse is also haunted by several other apparitions, most of them dressed in 1930s apparel: a distraught young woman in a wedding dress and a man wearing a double-breasted suit and appearing to be a lawyer. Even a shoe-shine boy has made an appearance.

A workman who helped renovate the building in 1992 reported, "Strange things happened there that have never happened at another job site. I think there are people there who died and never left."

The last man hanged in Minneapolis in 1898, John Moshik, is said to haunt the old Hennepin County Courthouse building. He was sentenced to death in the fifth floor Chapel Courtroom and has been seen there at night by "custodians, lawyers and even judges." In the 1950s, the fifth floor was remodeled and the Chapel Courtroom no longer exists, but that hasn't stopped this ghost. "Cold winds, an apparition of Moshik, odd movements and unexplained shadows are still reported."

ONE LAST DEATH

Although the death penalty is no longer the law of the land in Minnesota, while doing research on this book, I came across a very recent murder that took place in front of the Carver County Courthouse.

In 2001, after receiving a complaint, a state trooper purposely ran over a turkey in front of the courthouse and then wrung its neck. A lawyer for the county said "the turkey had become a mascot to employees, who often fed it." A Chaska police sergeant wrote, "We believe the trooper's actions constitute a violation of the (animal cruelty) statute."

The case was moved from Carver County to Renville County to avoid conflict of interest issues. The United Poultry Concerns urged its constituents to write the district attorney and request that the trooper be prosecuted.

However, the prosecuting attorney decided to drop the case. He felt that the trooper acted in "good faith" by running over the turkey in broad daylight in the middle of town, as he had been advised to do by a DNR employee. The United Poultry Concerns president was angered by the decision, claiming that it "compounds (the) crime against the defenseless bird and those who fed and befriended her." ▨

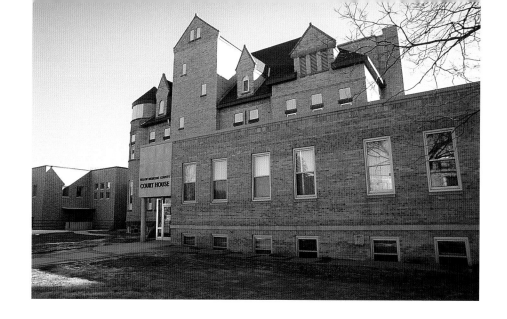

ABOVE Yellow Medicine County Courthouse, Granite Falls, 1889, Romanesque Revival

BELOW Pine County Courthouse, Pine City, 1939, PWA

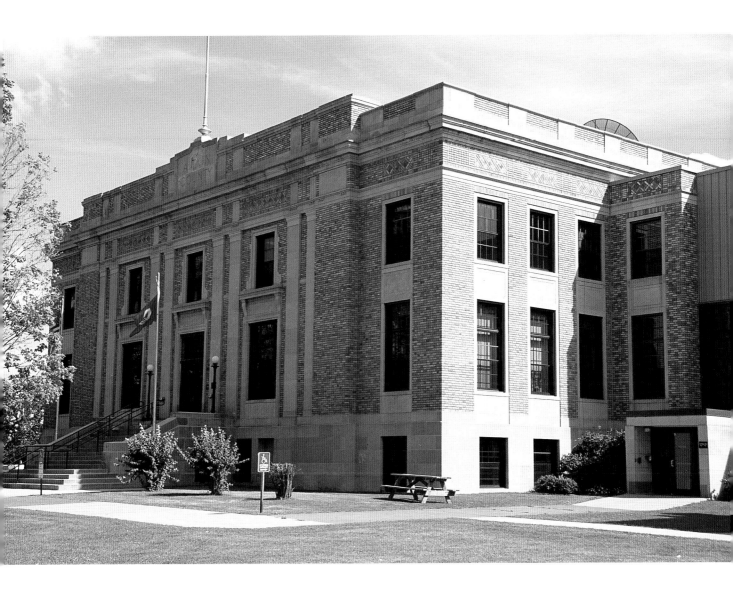

ABOVE Aitkin County Courthouse, Aitkin, 1929, Beaux Arts, National Register (1982)

NEXT PAGES Courtroom in the Brown County Courthouse, New Ulm

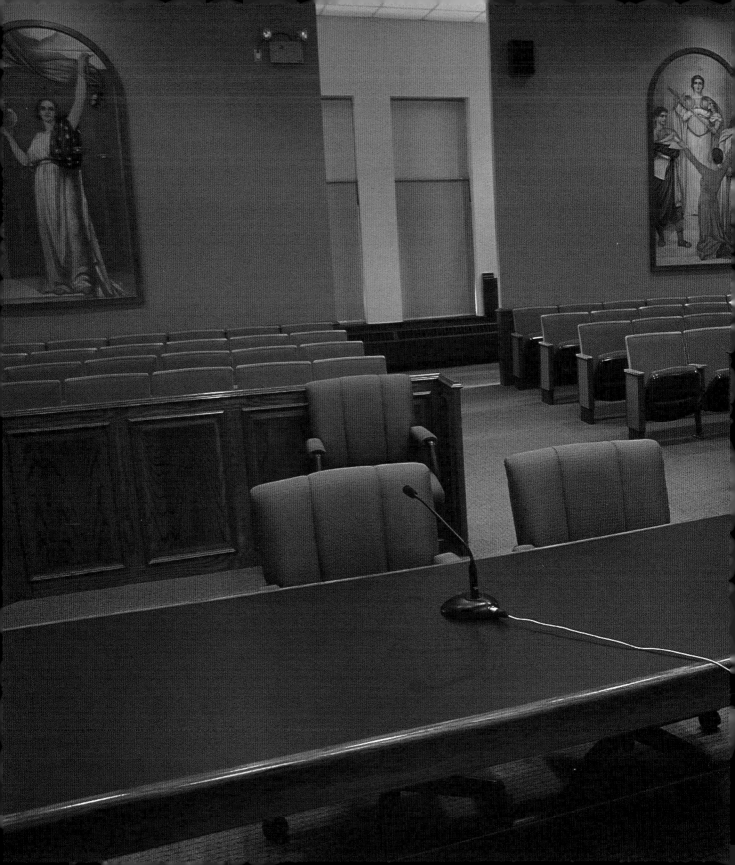

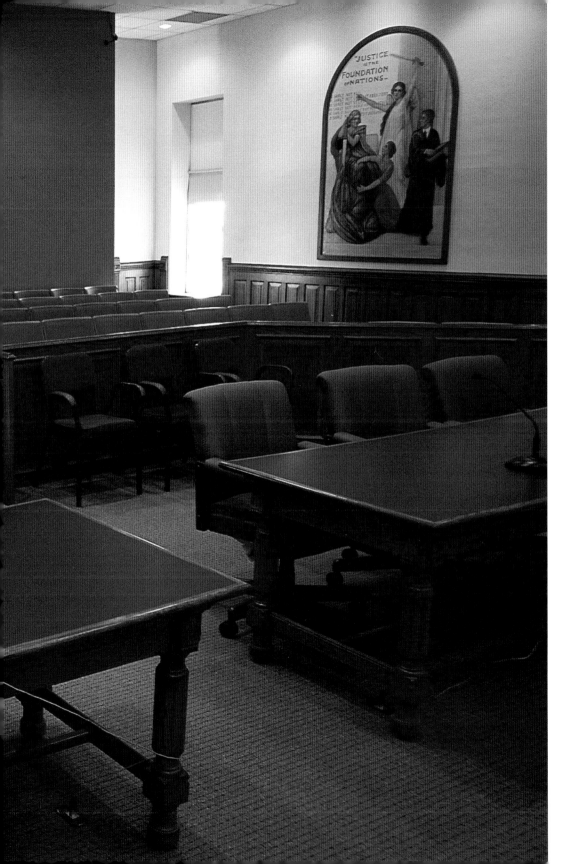

ABOVE Clay County Courthouse, Moorhead, 1953

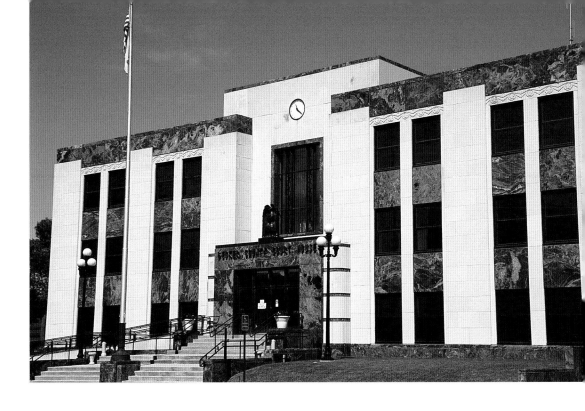

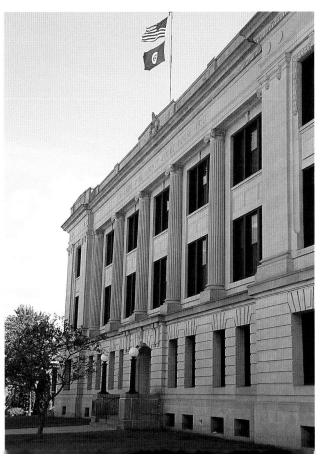

ABOVE Becker County Courthouse, Detroit Lakes, 1942, Art Deco

LEFT Crow Wing County Courthouse, Brainerd, 1920, Beaux Arts

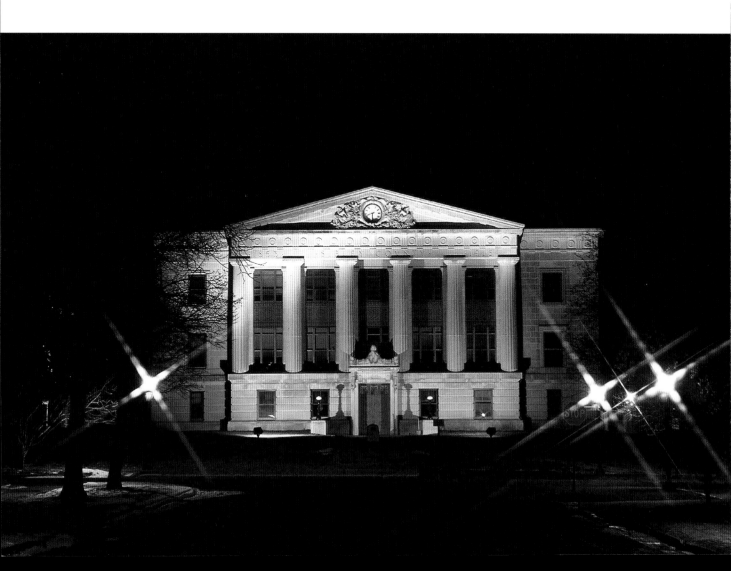

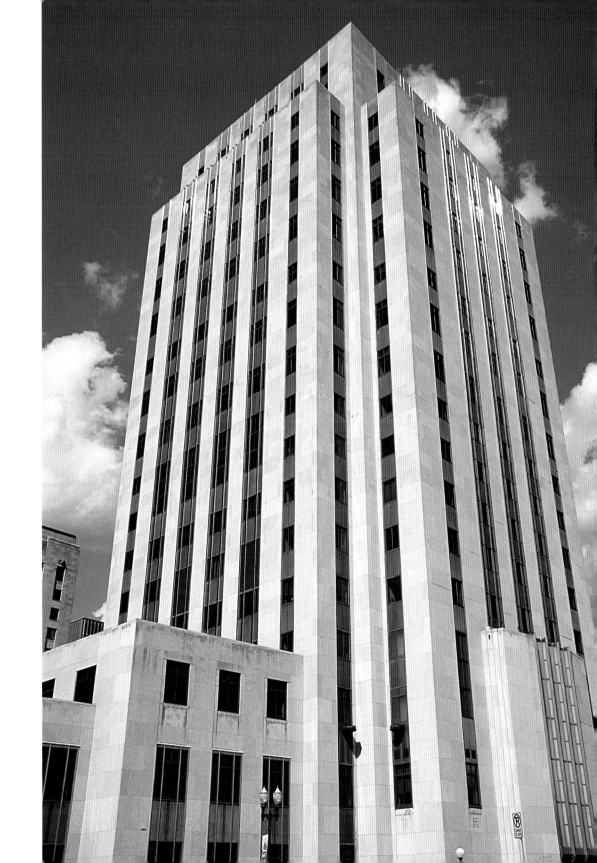

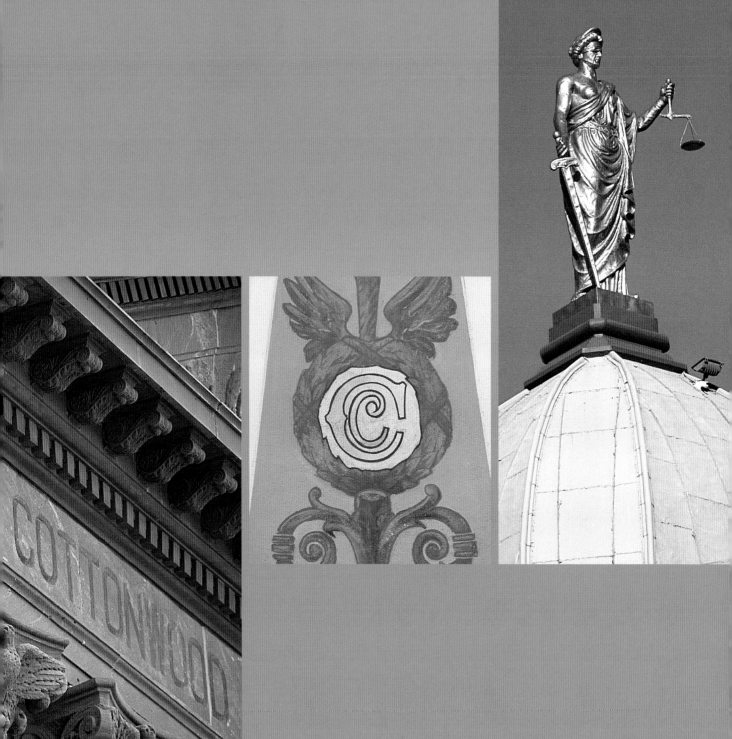

CARING FOR A COURTHOUSE

ON EACH END *of Lake Pepin, which is a twenty-six-mile-long bulge in the Mississippi River, there is a Minnesota county courthouse: Goodhue County Courthouse in Red Wing to the north and Wabasha County Courthouse in Wabasha to the south. I have a small house on the river halfway between the two courthouses. As I was writing the end of this book, I decided I would visit both of them, knowing that they represent two different ways of maintaining an older courthouse. ¶ First I went to find Wabasha's old courthouse, or what remains of it. The 1891 courthouse was once of the Romanesque variety: a ponderous gabled and towered red brick building with tall arched windows and lovely big hallways and huge courtrooms. ¶ Then, in the 1930s, the top third of the building was cropped off—all the gables, the* ☞

large corner tower, the pitched roof—and new brick, which only somewhat matches the old brick, was used to construct the new top third of the flattened building. The current county recorder told me this truncating was done to give men work during the Depression, "and to fix some other problems."

What had once made this stocky old building Romanesque has been effectively removed. Then, in the mid-century, an addition was jammed on to what had been the entrance to the old building. This one-story addition was built of a darker brown brick and sticks out on one side from the old building with no apparent

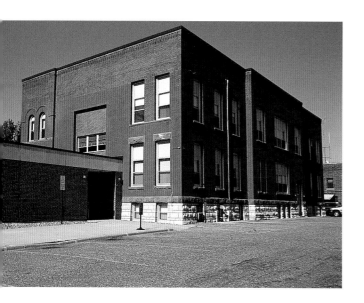

entrance, turning the cobbled-together structure into the shape of a hammerhead shark.

There is no signage on the building that tells you it is the Wabasha County Courthouse. When I walked into the old part of the building, the first thing I noticed were the four-feet wide beige worms wriggling down the hallway's ceilings, the air-conditioning system that Honeywell installed years ago.

Walking into an old courtroom on the second floor I see that the top third of all the windows have been boarded up, the ceiling has been dropped, the floor is carpeted, and the walls sheetrocked. All that remains in the building that is original is the old oak furniture and woodwork: the beautiful wood and metal benches, the handsome judge's bench, and lovely oak posts decorated with oak leaves.

※ ※ ※

Although I have been to Red Wing many times, I had never noticed the old courthouse, now used as the county administration building. I only knew which building it was by its location on a map. It is situated on the "mall," which is formed by two one-way streets running perpendicular to the Mississippi River, close to the post office and the library. When I mentioned I was going to look at this courthouse, people would

PREVIOUS PAGES, LEFT TO RIGHT Detail, Cottonwood County Courthouse, Windom; mural detail, Cottonwood County Courthouse; Lady Justice, Beltrami County Courthouse, Bemidji; window of the Hubbard County Courthouse, Park Rapids

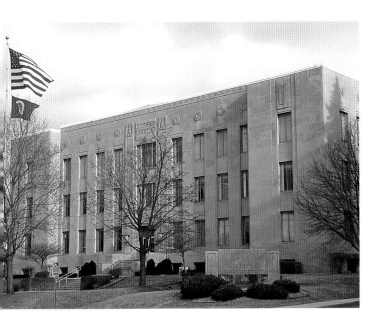

The building has been very well maintained. Beautiful marble walls are bordered with the names of all the townships in the county. In the middle of the second floor an open atrium shows off lovely two-story murals of the Art Deco period. Colorful stained glass decorates the dome.

Entering the largest courtroom, I was transported back into all the elegance of the 1930s. Fantastic Deco light fixtures illuminate the ceiling and graceful long wooden benches fill the room.

I think one of the reasons this courthouse has been maintained so well is that the county hasn't tried to force the building to handle more than it can. Instead, Goodhue County has built a new justice center, a new county sheriff's department and jail, and a new county highway building. The 1932 courthouse continues to be used for county commissioner meetings and for some court cases.

⬚ ⬚ ⬚

What should happen to old courthouses? In Minnesota, some counties are building third- and fourth-generation courthouses. Meanwhile, the old courthouse buildings are transformed into museums, office buildings, or, more often, torn down.

tell me they knew where it was, but when I questioned them, they were thinking of city hall. The courthouse is a rather unobtrusive stone building, surrounded by trees.

In the early 1930s, Goodhue County needed a new courthouse. It was a good time to construct a monumental building. Because of the Depression, labor and materials were cheap. Built of light-colored granite, its boxy, three-story shape is slightly streamlined by vertical piers and windows. In *Architecture of Minnesota,* its style is called, "PWA Fascist Moderne;" which sounds rather scary.

LEFT Wabasha County Courthouse, Wabasha, 1892

ABOVE Second Goodhue County Courthouse, Red Wing, 1932, Art Deco

While there is no easy answer to this question—it varies so much depending on an individual county's needs and financial abilities—it is worth examining, for the way a county cares for its old courthouse often defines how it is doing economically and its own sense of pride.

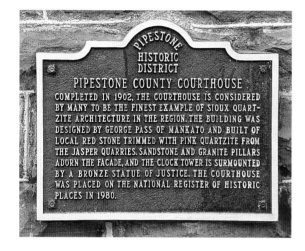

THE NATIONAL REGISTER

While there are eighty-seven counties in Minnesota, there are many more county courthouse buildings, counting the three courthouses in St. Louis County, and the older courthouses that have been replaced but are still standing. Of the 90-plus courthouse buildings, 55 of them are listed on the National Register of Historic Places (NRHP).

The NRHP was created in 1966 to "to coordinate and support public and private efforts to identify, evaluate, and protect our historic and archeological resources." The register includes not just buildings, but also historic districts of towns, trains, bridges, cemeteries, and even carousels and petroglyphs. While a listing confers honor and can often bring tourism dollars to an area, it doesn't necessarily require the owner to maintain the building in any special way.

However, if a NRHP–listed structure is fundamentally changed, then the listing can be revoked. This has happened in at least four instances to county courthouses: Steele, Chisago, Murray, and Lake of the Woods.

While delving through the NRHP file of the Otter Tail County Courthouse, I was surprised to learn that officials there had tried to decline the proposed NRHP designation of their county courthouse in 1984. They feared losing control of their buildings, and preferred "to preserve them without any meddling from the state and federal government." One wonders why they hadn't let this be known before the paperwork was completed.

The administrator of the Otter Tail County Historical Museum was disappointed by the officials' reaction. "It's a national recognition. . . . I can appreciate local government control . . .

ABOVE Historic plaque, Pipestone County Courthouse, Pipestone

but [listing on the National Register] is not something to be afraid of."

A few days later, the site was found eligible for the National Register and was finally listed later that same year. In fact, such a listing demands a review process only if a change or renovation involves federal funds.

⊞ ⊞ ⊞

Some Minnesota county courthouses that have been considered for listing on the National Register have either been found lacking in some way, or the buildings have been so substantially changed from their original construction that they are no longer deemed eligible.

Such a decision was made about the Freeborn County Courthouse. In a letter to one of the commissioners, it was stated, "It is apparent from information submitted to this office that

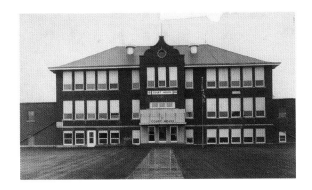

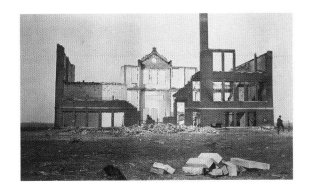

the courthouse occupies a special place among the residents of Albert Lea. However, it is also apparent from the photo documentation that severe alterations made to the building substantially compromise the physical integrity of the building. . . ."

101

DESTROYED

Sometimes new courthouses have to be built because the old one is destroyed. The Otter Tail County Courthouse was destroyed by a tornado in June of 1919 that lifted off the top two floors of the forty-year-old building. The Faribault County Courthouse lost its chimney to a tornado in 1936. But fires were the real worry, especially for the early wood-framed courthouses. The last courthouse in the state built of wood was for newly established Clearwater County in 1902.

ABOVE, LEFT Lake of the Woods County Courthouse, 1911, Baudette

ABOVE, RIGHT This old school building, which became the county courthouse in 1909, was rebuilt after a 1910 forest fire.

Big Stone County's first courthouse burned down in 1885 in what was probably not an accidental fire. The building was also used as a jail and two men were locked in it at the time of the fire: "Tom Cronan, sent up from Graceville, and crazy man Hurste." The jailer left the two men eating dinner and then, within minutes, the building was on fire. Cronan was rescued but Hurste was never found.

Cronan described what happened, "Hurste took the kerosine can and commenced throwing kerosine into the stove. I put my hand on him and told him to stop. He then hit me on my head with the can. We got a scuffling and the stove was tipped over. He bit me on my hands, and my face and on my neck. . . ." Cronan was found with scratches on his hands and face and it was conjectured that Hurste escaped. Luckily, the county records were saved.

The second Rice County Courthouse, built in 1875, burned down in 1931, but two fireproof wings added in 1923 did not burn. "A bitter controversy followed as to whether the fire proof wings, which had saved the records, should be used as a nucleus for a new building." The county decided on building a new structure and the ruins were torn down.

In 1909 a mysterious fire conveniently burned down the old wooden courthouse in

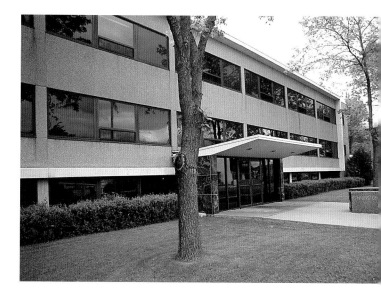

Red Lake Falls, allowing the county to build a new courthouse and retain the county seat. Thief River Falls was so upset by what had happened that they split off into a new county—Pennington—and built a new courthouse that the citizens of Red Lake County, ironically, had to help pay for.

⊠ ⊠ ⊠

Old courthouses, if they're not destroyed, are often reused for historical museums, as in Sibley County where the 1879 courthouse is home to the Joseph R. Brown Minnesota River Valley Center.

ABOVE Pennington County Courthouse, Thief River Falls, 1955

In 1977 the 1900 Hubbard County Courthouse was given to the county historical society free of charge. They just had to maintain it. This sounds easy but by 1997, the society was amazed how many problems an old building can develop from "gaping holes in the walls to bathrooms that need redecorating to basement rot."

In Chisago County the 1876 wooden courthouse was moved to a field near Palmdale in 1990. Before its removal the building, situated on a peninsula, was the last frame courthouse in use in Minnesota. A new government center took its place in Center City.

❋ ❋ ❋

Many counties decide for a myriad of reasons—usually financial—that the old historic courthouse has to go. Making these decisions can be a long and bitter process and, often, leaves a community with a real sense of loss.

Preservationists fought for over a decade to save the Sherburne County Courthouse, built in 1877, then added on to and renovated for nearly a hundred years. By 1980 the county had moved all its offices out of the building. The county board wanted to tear it down and sell the land to pay for a new addition to the new government building. In 1995 the county paid to have it razed and it took only a morning to pull it down.

The 1892 Murray County Courthouse, a solidly built Romanesque, was pulled down in 1981. After years of judges and auditors complaining that the building was falling apart, the demolition crew had a terrible time pulling it down. The steel cables they used broke nine times before the tower at last was toppled. "It's being held together by the ghosts of Norwegian bricklayers," a spectator suggested.

The Lake of the Woods County Courthouse was demolished June 6, 2001. While some county courts used schoolhouses temporarily in their early years, this county courthouse took over a 1911 school building and used it for county offices starting in 1955. Claiming it would have cost $400,000 to fix the structure, the county instead built a new one for over $3 million dollars. The county auditor stated the old building "was not efficient for operating the government. It was not energy efficient at all."

Another way that old county courthouses can be lost is by being cannibalized by their own additions. Over the years, they are expanded and remodeled so drastically that not much is left of the original building. This has happened in counties including: Mower, Traverse, Redwood, and Yellow Medicine.

PRESERVED

Many counties have decided to keep and renovate their old courthouse buildings, especially in areas of the state with little population growth.

The Cottonwood County Courthouse, which has been described by the Minnesota State Bar Association as "of a style and dignity easily mistaken for a state capital," has been wonderfully maintained. A forty-two-page publication on the courthouse was produced for its centennial that gives a sense of the pride and satisfaction the citizens of this county take in their fine 1903 Romanesque Revival building.

In the early 1980s the Rock County Courthouse, a Romanesque building finished in 1888, was under attack. It, like many old courthouses, simply didn't meet the accessibility requirements and needed major work. However, the county realized it had "a wonderful piece of local history," and, rather than tear it down, decided to renovate it.

In 2000 the 1888 Winona County Courthouse faced a serious problem. It had been placed on the National Register in 1970 and in 1971 a major renovation was funded, which saved the building. Then, in 2000, broken water pipes caused catastrophic flooding, which destroyed offices in the lower floors. Mold started to grow on walls and ceilings. County officials were thinking of gutting the courthouse.

But not only was it saved, much of the building was returned to the way it looked originally. Even the old fireplaces were restored. Insurance helped pay for over half the work and the Minnesota Historical Society chipped in with $50,000 for the exterior work.

In 1989, when the *Pipestone County Star*

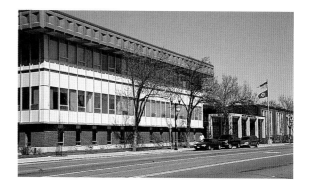

ABOVE, TOP Kittson County Courthouse, Hallock, 1965

ABOVE, BOTTOM Anoka County Courthouse, Anoka, 1955

asked its readership how they felt about restoring their old county courthouse, 80 percent of the respondents said they wanted a complete restoration with answers like, "Let's keep the courthouse a showplace. It can never be replaced. Restoring now could give this building another ninety years of life."

In 1996, almost a hundred years after it was built in 1899, the building was rededicated. Part of the oath in the dedication was: "We will respect the splendor of this historic edifice. . . . We will strive unceasingly to quicken the sense of public duty and thereby transmit a heritage not less, but greater and more beautiful than was transmitted to us."

NEWER BUILDINGS

Of the ninety in-use county courthouses, eighteen counties have constructed new buildings since 1970: Benton, Chisago, Dakota, Goodhue, Hennepin, Hubbard, Isanti, Lake of the Woods, Marshall, Meeker, Murray, Nobles, Olmsted, Roseau, Scott, Sherburne, Wadena, and Washington; and eleven more since 1950, including: Anoka, Carver, Chippewa, Clay, Fillmore, Itasca, Kandiyohi, Kittson, Pennington, Pine, and Polk.

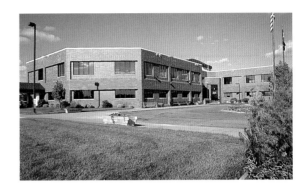

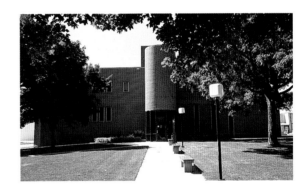

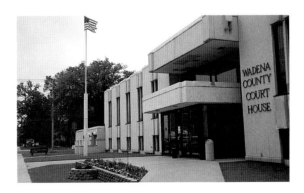

ABOVE, TOP Sherburne County Courthouse, Elk River, 1978

ABOVE, CENTER Lyon County Courthouse, Marshall, 1939–75

ABOVE, BOTTOM Wadena County Courthouse, Wadena, 1970

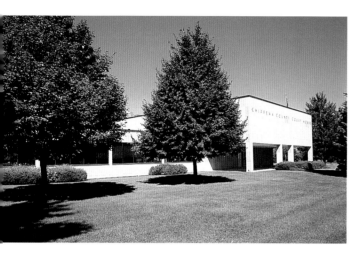

Will any of these new courthouses be considered pieces of great architecture in the future, possibly listed in the National Register? It might seem unlikely, as often with newer buildings counties are not so concerned about how the building looks, but rather with how it serves the community.

The director of the Chippewa County Historical Society recently wrote about their county courthouse, finished in 1958, "It was not built with the grandeur of many earlier court houses in the state but with utility of service and availability to the handicapped being the first concerns. The offices that citizens most visit are close to the main entrance door."

Architect Victor Gilbertson expressed some opinions on these newer courthouse buildings in his book, *Minnesota Courthouses*. He gives a nod to the 1957 Chippewa County Courthouse, designed by Robert Cerny, calling it, "a strong statement of modern architecture." He calls the 1974 Meeker County Courthouse, built by Genesis Architects, "an excellent example of contemporary architecture." But he finally answers my question when he says of the Kandiyohi County Courthouse finished in 1966:

> *The 1965 Kandiyohi Courthouse has been criticized for its design from the time it was built. Critics complained that it had an agitated shape. That may turn out to be a proud distinction. One day it may be on the National Register as a good example of modern architecture of the period.*

AN OLD RIVALRY

In 1995 a county seat rivalry came to life again. Roseau County needed a new courthouse. The Marvins, owners of Marvin Windows and Doors, offered to build the county a "beautiful new state-of-the-art building with an attached social services department and jail" to the tune of $4.5 million dollars. There was just one condition: instead of staying in Roseau, the courthouse would need to be built in Warroad, the Marvins' hometown.

ABOVE Chippewa County Courthouse, Montevideo, 1957, International Style

RIGHT, TOP Historic Roseau County Courthouse, Roseau, 1913, vernacular interpretation of Classical Revival, National Register (1985)

RIGHT, BOTTOM New Roseau County Courthouse, Roseau, 1996, postmodern interpretation of Beaux Arts

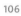
106

The rivalry between Warroad and Roseau, twenty miles apart near the Canadian border, is legendary. Both towns turn out great hockey teams and they battle it out all winter long. So when the offer of the new courthouse was made, the people of Roseau wanted nothing to do with it. A petition for a referendum to change the county seat fell short of the required names after the Roseau County Board removed 286 names.

While at first cries of foul play rang out and a civil suit was filed, in the end Roseau kept its county seat. The taxpayers paid almost $3 million dollars for the new building, designed by Duluth architects. It incorporates "several elements from the old courthouse," and even features a gold-leaf dome in the main foyer.

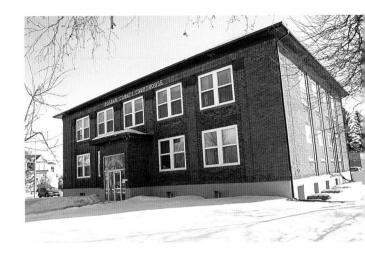

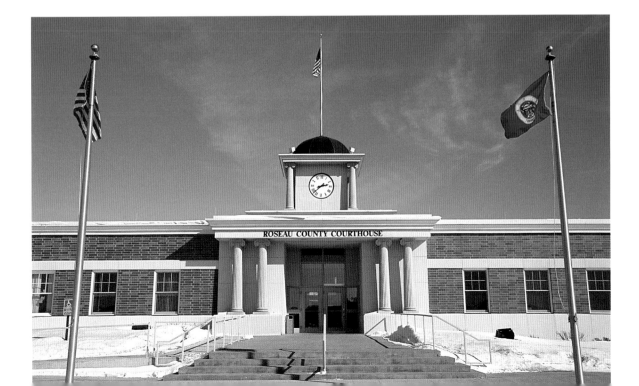

means group or retinue. In the Middle Ages, *court* was used to describe the family, advisers, and familiars of a sovereign. When the local governments of America were being formed the word was co-opted for use by the county seats, which called their domain a "court house."

But newer county buildings are no longer always called "courthouses." More often they are tagged government centers or law enforcement centers or county administration buildings. The day of the county courthouse might pass, almost without notice, as the word disappears from our lexicon.

A COURTHOUSE BY ANY OTHER NAME

The saga of Minnesota county courthouse buildings will go on as long as the state exists, but the archetype of one clearly defined building where all the county's tasks are administered under one roof is waning. Many suburban counties are feeling the push of population growth and additions sprout off of newer buildings in Anoka, Carver, Dakota, Scott, Washington, and Wright counties like barnacles on a ship's hull. These rambling facilities end up looking more like shopping malls than unified, dignified structures.

What's also in dire danger of extinction in our state is the word "courthouse." The word *court* comes from the Latin word "cohors," which

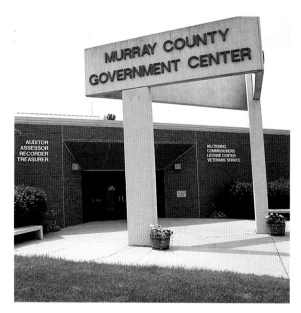

ABOVE, LEFT Carver County Courthouse, Chaska, 1994

ABOVE, RIGHT Murray County Courthouse, Slayton, 1981

ATOP THE DOME

For the grand finale of this narrative on county courthouses, I visit Hastings to see one of my favorites. In 1974, the city of Hastings bought the old Dakota County Courthouse, located two blocks off their main street, to use as their city hall. They have since taken extraordinary care of it.

As I drive across the bridge over the Mississippi River, the salmon-colored brick dome of the 1870 courthouse shines in the sun. This building is a marvelous confection, a wonderful cakelike structure of a domed cupola and four mansard-roof towers decorated with white garlands.

I park in back and walk around to the north-facing front so I can take in the building's full glory. The courthouse now shares its square with two handsome low limestone buildings, an office wing and the sheriff's office. I step back and try to imagine how this lovely courthouse must have appeared in its heyday.

Actually, what I am really imagining is an event that took place at the turn of the twentieth century when the carnival came to town. Several blocks around the courthouse would be roped off for this annual affair.

The highlight of the carnival was when a woman performer would step out onto the courthouse dome, attach her head to a guide wire, and slide down the wire to the corner of 3rd and Vermillion Streets. "A group of men held a canvas drop cloth at the bottom which she would drop into—before she would slide into attached ground post."

And so I end with this nostalgic image, which captures the energy and enthusiasm of county government at the turn of the last century—a woman sailing through the air from the top of a garlanded courthouse dome into the future. ▦

109

ABOVE Scott County Courthouse, Shakopee, 1976

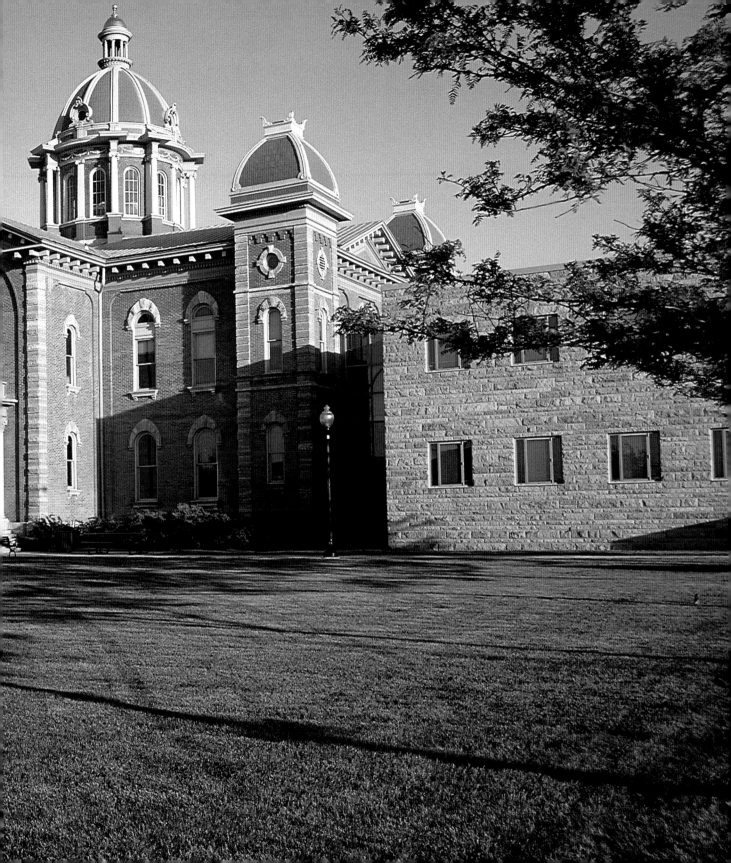

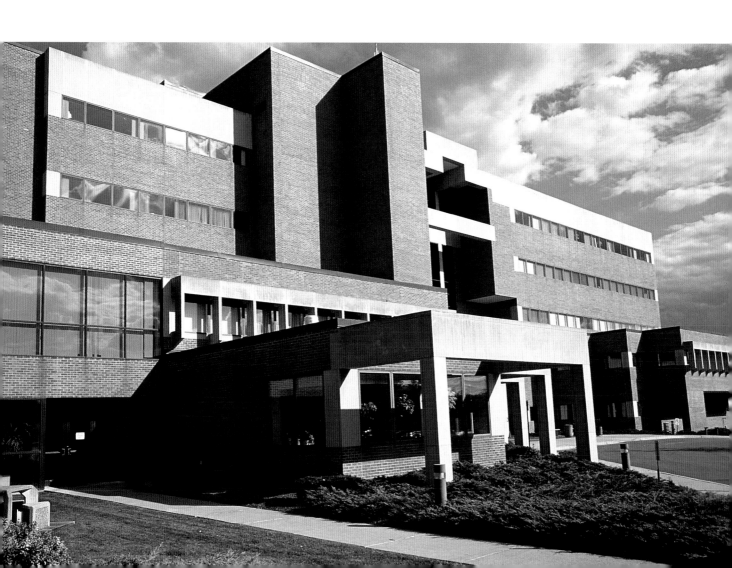

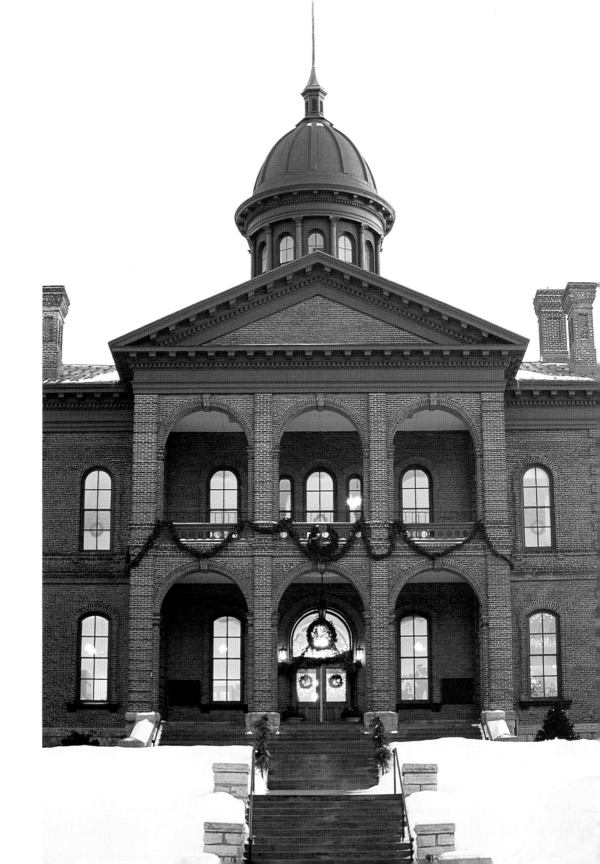

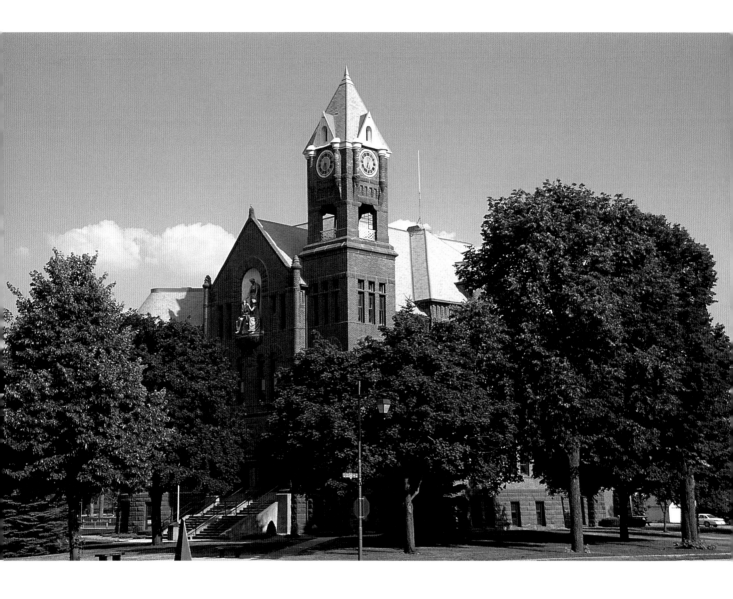

ABOVE Steele County Courthouse, Owatonna, 1891, Romanesque Revival, National Register (1976)

RIGHT, TOP Rice County Courthouse, Faribault, 1934, Art Deco, National Register (1982)

RIGHT, BOTTOM Benton County Courthouse, Foley, 1901, Romanesque Revival

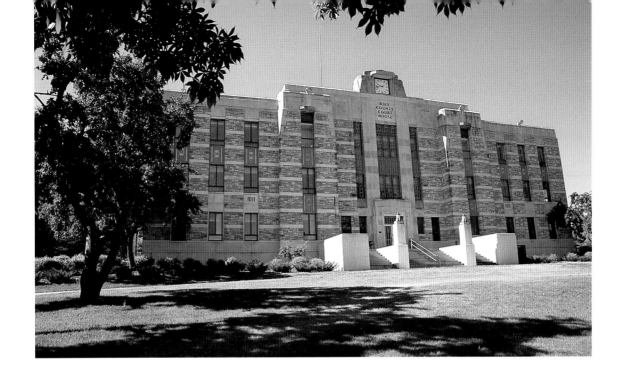

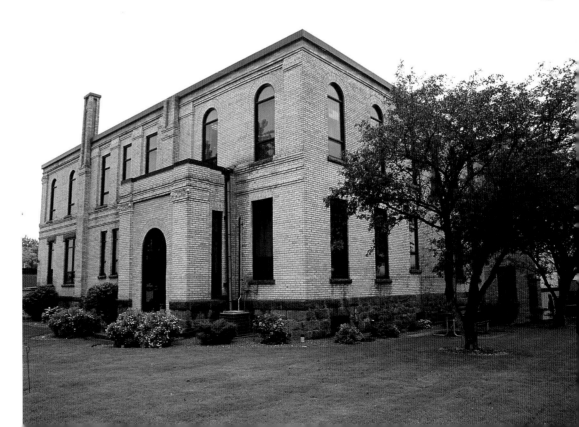

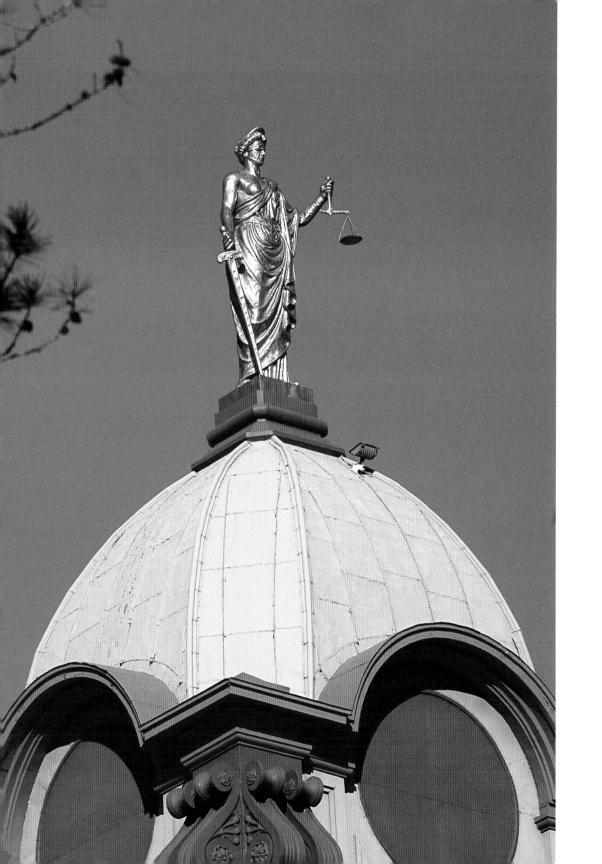

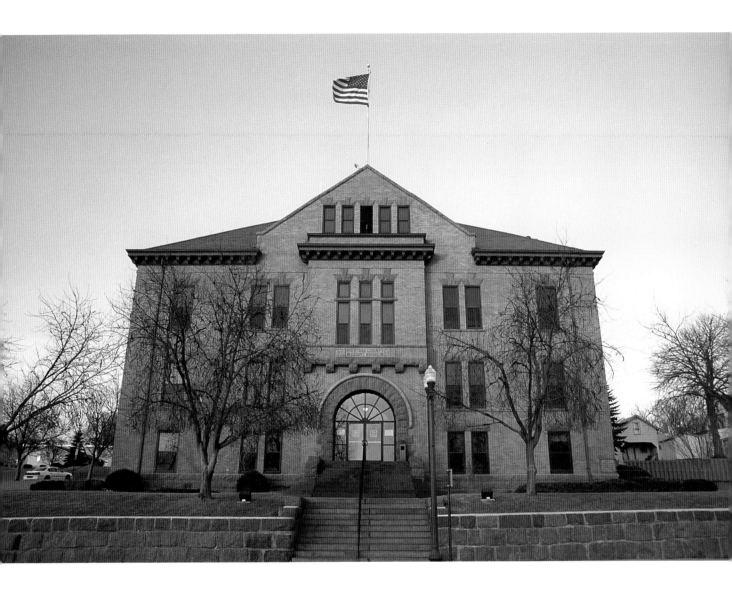

LEFT Dome of Beltrami County Courthouse, Bemidji, 1902, Beaux Arts, National Register (1988)

ABOVE Big Stone County Courthouse, Ortonville, 1902, Romanesque Revival, National Register (1985)

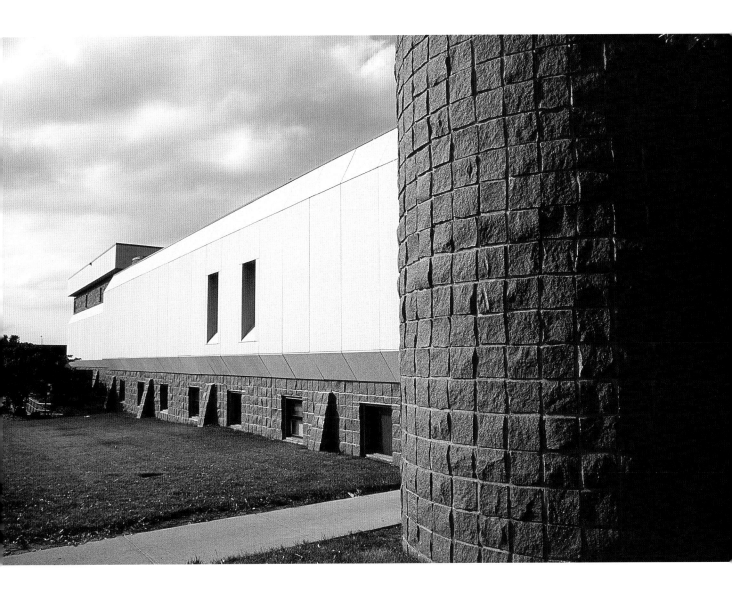

LEFT, TOP Dakota County Government Center and Courthouse, Hastings, 1974/2004

LEFT, BOTTOM Chisago County Government Center, Center City, 1973/1990

ABOVE Nobles County Courthouse, Worthington, 1974

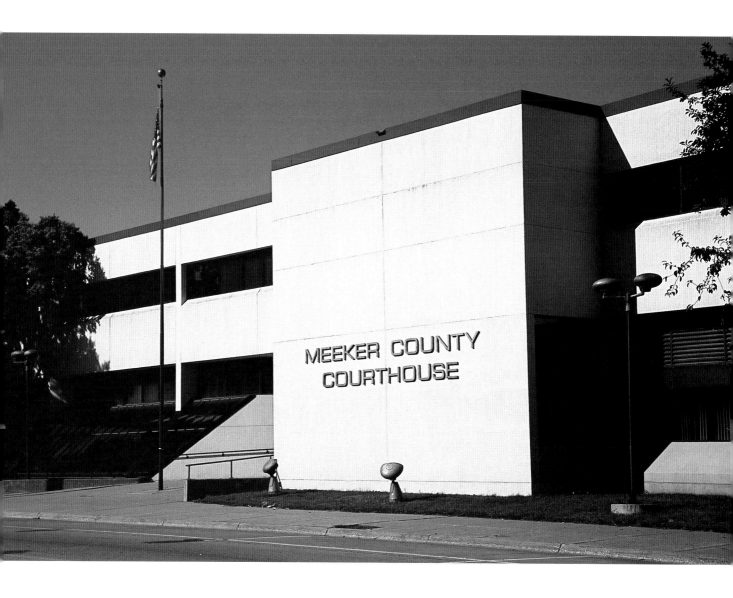

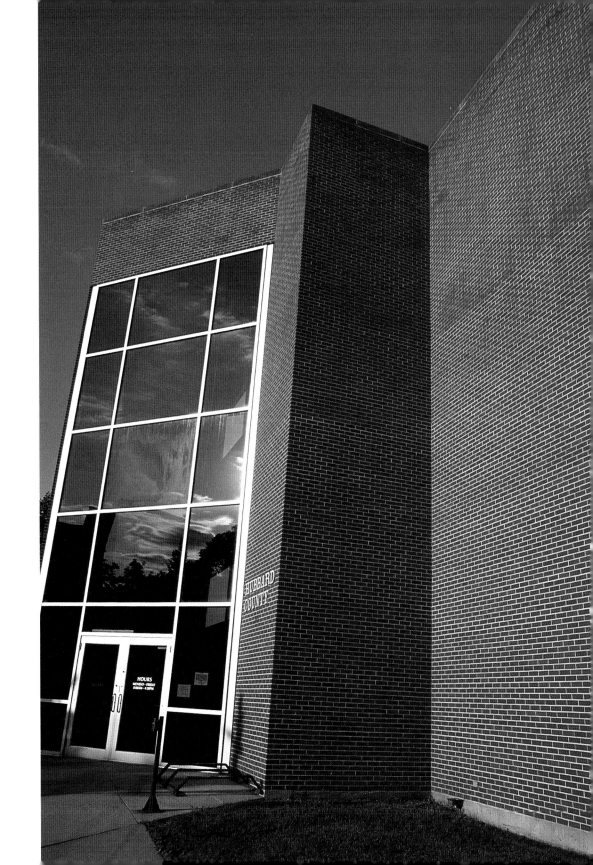

SELECT BIBLIOGRAPHY

The book that served as the bible for my research into Minnesota county courthouses was *The First 100 Years . . . The Minnesota State Bar Association.* Published in 1983 by the Minnesota State Bar Association, it is a wonderful compendium of information on the way the law works in Minnesota, and also offers brief, but thorough, historical sketches of each Minnesota county and the courthouses therein.

Inspiration came from an elegant, coffee-table book titled *Court House* published by Horizon Press (1978), with essays by Calvin Trillin, Phyllis Lambert, Paul C. Reardon, Henry-russell Hitchcock, and William Seale. This book's large-format, black-and-white photos of United States courthouses are works of art and the essays give both historical background on the courthouses and personal recollections.

But the largest repository for all the pieces of information I gathered was the National Register Archives in the State Historic Preservation Office (SHPO) at the Minnesota Historical Society in St. Paul. In the bowels of the building, I spent a couple happy weeks reading through the documentation in the files of all the courthouses listed on or considered for the National Register. Susan Roth and her colleagues were generous, helpful, and sometimes directive as I searched. In these files I found, and have excerpted in my text: National Register application forms, letters, newspaper clippings, essays, brochures, and other pieces of courthouse ephemera.*

Marion Cross's *Minnesota Courthouses* published by the National Society of The Colonial Dames of America in the State of Minnesota (1966); *A Guide to the Architecture of Minnesota* by David Gebhard and Tom Martinson (University of Minnesota Press, 1977); and *Ghost Stories of Minnesota* by Gina Teel (Ghost House Books, 2001) were all used as references. Also, *Lost Minnesota: Stories of Vanished Places* by Jack El-Hai, which tells of two of the county courthouses that were destroyed (University of Minnesota Press, 2000).

Murder in Minnesota by Walter N. Trenerry (Minnesota Historical Society Press, 1962, 1985) was invaluable to my understanding of how murders were handled in Minnesota for the first sixty years of statehood.

A note on the quotations taken from papers in the NRHP files: they have been reproduced as originally printed without adding "sic" to designate mistakes. I felt such an addition would be intrusive and somewhat patronizing and would take away from the delight I have felt in reading the originals.

A new book on Minnesota courthouses was released just as I was finishing my work: *Minnesota Courthouses: Watercolors of Historic Structures,* written and illustrated by Victor C. Gilbertson, FAIA, (Galde Press, 2005). Besides the lovely renderings of nearly all the Minnesota courthouses that have ever existed, the book provides an enormous wealth of knowledge on the architecture of each building. An information line at the bottom of the pages for each county gives the location, architect, contractor, date, materials, and cost of every county courthouse built in Minnesota.

I have also included stories taken from personal memoirs: *Jailhouse Stories: Memories of a Small-Town Sheriff* by Neil Haugerud (University of Minnesota Press, 1999), *Prairie Son* by Dennis M. Clausen (Mid-List Press, 1999), and even my own *Halfway Home: A Granddaughter's Biography* (Minnesota Historical Society Press, 1996).

The Internet proved to be helpful as most counties in Minnesota have websites that give pertinent information on their buildings. I also pulled off the Net the story of the murdered turkey from a couple sources, including www.upc-online.org; and information on ghosts from www.prairieghosts.com. Also, most of the information on the Duluth lynchings was taken from the Minnesota Historical Society's website: http://collections.mnhs.org/duluthlynchings/

Two women dug into archives to help me out: Debbie Erickson at the Office of the County Manager in Ramsey County sent me articles on the *Vision of Peace,* and Cindy Thury Smith, Pioneer Room Curator for the City of Hastings, sent me information on the old Dakota County Courthouse and the carnival woman.

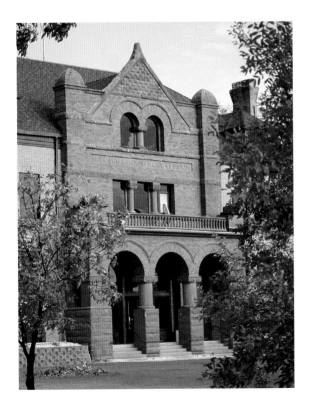

ABOVE Marshall County Courthouse, Warren, 1910, Victorian Romanesque

ACKNOWLEDGMENTS

A large project like this involves digging into many archives and picking many brains. I want to thank all the people who have helped me along the way.

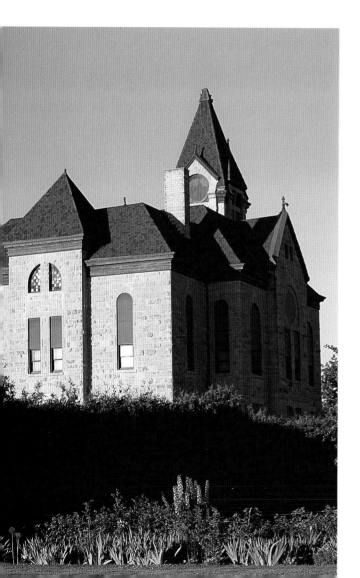

Thanks must first go to Pamela McClanahan, who set me on the path, then gave me my head. Gerd Kreij, who allowed me to read whole sections to her when I was rassling pretty hard with it. Kay Grossman, who knows her Minnesota history and directed me to some great stories. Again, Susan Roth et al. for my shared time with them in Minnesota's State Historic Preservation Office (SHPO) archives. Denis P. Gardner, the fact-checker, who nailed everything down tight. Pete Hautman, my life partner, who is my first reader and my last before any project goes out into the world.

A big thanks to everyone else I talked to about courthouses. One of my favorite anecdotes, for which I never found a place in the text, concerns a particular use of courthouses. Several people told me how they always scout out a courthouse when they are traveling, because it offers a nice place to rest, even just sitting on the steps, and always has good bathrooms. What better way to serve the people.

MARY LOGUE
Golden Valley, Minnesota

LEFT Houston County Courthouse, Caledonia, 1883, Romanesque Revival, National Register (1983)

PHOTOGRAPHER'S NOTE

Of all the historic buildings on the Minnesota landscape, courthouses are some of the grandest. Traveling to all eighty-seven counties, I realized how fortunate we are to have these civic icons, some of which are now almost 150 years old.

Walking the grounds of some of our oldest courthouses, it is not hard for me to step back in time and imagine the grand dedication ceremony with all the pageantry of the Gilded Age. The band is playing a favorite Sousa number; men and women are admiring the tower clock or choosing a shady spot for their noon picnic. After a lunch of fried chicken, the courthouse staff hands out small American flags and encourages everyone to come up close to the bandstand to hear speeches from the mayor and other civic leaders. Later in the afternoon the new courthouse is open for self-guided walking tours and, for those who can afford it, family pictures on the marble front steps. As evening approaches, children and adults alike wait excitedly for the fireworks. The display will illuminate the entire courthouse square and be the perfect ending to a day filled with community pride and a new sense of optimism.

My hope is that we in Minnesota will continue to maintain and preserve our grandest of all historic buildings—our county courthouses.

I want to thank my editor, Pamela McClanahan, and the entire staff at the Minnesota Historical Society Press for having the vision for this book and for the series, *Minnesota Byways*. I also want to thank the many courthouse staff members who took the time to show me courtrooms, attics, and basements in my quest to capture the right image. Last, but certainly not least, I thank my family for their ongoing love and encouragement.

DOUG OHMAN
New Hope, Minnesota

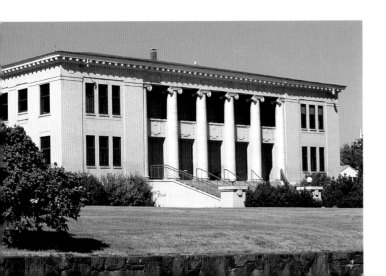

LEFT Cook County Courthouse, Grand Marais, 1912, Classical Revival, National Register (1983)

INDEX

128